IMAGES
of America

PROSPECT PARK

IMAGES
of America
PROSPECT PARK

Ronald P. Verdicchio and the
Prospect Park Community Study Group

ARCADIA
PUBLISHING

Published by Arcadia Publishing
Charleston, South Carolina

Printed in the United States of America

Library of Congress Control Number: 2014933315

For all general information, please contact Arcadia Publishing:
Telephone 843-853-2070
Fax 843-853-0044
E-mail sales@arcadiapublishing.com
For customer service and orders:
Toll-Free 1-888-313-2665

Visit us on the Internet at www.arcadiapublishing.com

*To the founders of Prospect Park, who were
brave enough to carve a piece of home.*

CONTENTS

ACKNOWLEDGMENTS

We would like to extend our gratitude to the many people who assisted us in the research and production of this publication. Specifically, we would like to thank Thomas F.X. Magura for his invaluable insight and extensive knowledge of the borough of Prospect Park. Unless otherwise noted, all images appear courtesy of Thomas F.X. Magura. We appreciate the support from the Prospect Park Borough Council, Prospect Park Police Department, Prospect Park Volunteer Fire Department, and the borough clerk's office of Prospect Park. We thank the religious community, particularly New Hope Ministries, Eastern Christian School Association, and the Holland Home, for their availability and compassion throughout our study. For access to their photographic archives, we thank Evelyn Hershey of the American Labor Museum/Botto House National Landmark and Heather Garside and her staff at the Passaic County Historical Society. We are grateful for the logistical support of Elaine Bush of William Paterson University College of Education. Lastly, we thank our colleagues and fellow students of the Prospect Park Community Study Group, who served as field research assistants—Jean Gervais, MAT (class of 2013); Phillip Gorokhovsky; Sarah Johnson (class of 2014); and Rita Vander Stad (class of 2014).

INTRODUCTION

It is almost a cliché, but America is a nation of newcomers. This fact has been made evident in the past 25 years by the torrid pace of immigration of foreign-born people to the United States since the 1970s. This influx of newcomers and their diverse countries of origin are in stark contrast to the families that found their way to the Passaic Valley of Northern New Jersey in the late 1800s and the start of the 20th century. The relatively young history of Prospect Park (114 years) is one of family, the ethics of hard work, thrift, and community volunteerism centered on Christian values. In the chapters that follow, we chronicle, through photographs, artifacts, and written narratives from two years of ethnographic study, the transformation of Prospect Park from a predominately "Holland-Dutch" enclave to one that mirrors the cultural diversity of New Jersey and the New York metropolitan area.

The basis of the book's content is a collection of oral histories, archival research, interviews, observations, anecdotal references, and our own volunteer participation. We note at the outset that ethnography is not an exact science and that the historical record remains incomplete. To that end, we have culled our narrative from people who have lived, worked, attended schools, and worshiped in Prospect Park for most, and, in some cases, all of their lives, as well as newcomers to the borough. This narrative begins with the early history of the borough.

The Borough of Prospect Park was founded on March 13, 1901, when the State of New Jersey granted a charter to incorporate the borough. The borough was carved from a section of Manchester Township. Much of the land that constituted the early borough was part of the Hopper, Planten, and Westervelt estates. The size of the borough is less than one-half of a square mile. This led to one of many borough nicknames, "one half square mile of Dutch." The name Prospect Park first appeared on a development map of the estate of Cornelius P. Hopper in 1872. It is not clear why this name was selected for the new borough.

Prospect Park borders Paterson, also known as Silk City, to the south. Many of the immigrant Dutch workers lived in the northern part of Paterson and as time went on they pushed north "up the hill" to what is now Prospect Park. The early settlers of Prospect Park were craftsmen and mill workers, many of whom lived in neighboring Paterson, Clifton, and Passaic. The location was convenient for workers who came from the Netherlands to the Passaic Valley to work in the textile industry in Paterson. In 1901, with the charter of the new community, Prospect Park was settled, and the workers brought their families and, later, their churches from neighboring communities. Documents show that the first mayor of the borough, Adrian Struyk, loaned the new borough money to pay bills to get the government functioning. The first municipal "building" was in the basement of the new mayor's house.

Religion was the cornerstone of Prospect Park from its founding. When Dutch workers and their families moved to the borough, they brought their churches and their Christian religious values with them. Religion was the glue of the community; the Sunday blue laws were put in place to strongly encourage, if not enforce, church attendance on Sunday. There was to be no activity

but church service, often twice. Hanging out wash, house painting, gardening, and the like were prohibited, and the law was strictly enforced. One longtime resident quipped that a man had to put on a shirt and tie to take the garbage out on Sunday! There were no bars, liquor stores, or nightclubs in the borough (although there was talk of a brewery in the basement of a grocery store). A resident noted that some of the men would walk down Haledon Avenue to Paterson after morning services on Sunday and enjoy a beer at Piersma's. In the 1920s, a Catholic church was built in the northwest section of the borough. It was attended by a small but growing Italian immigrant population. They were referred to as "the Italians up there."

Prospect Park community life was characterized by the spirit of volunteerism, as illustrated by Mayor Struyk's loan to the borough. The volunteer fire department was and remains a center for volunteer activity. The Boys Club and the Police Athletic League (PAL) were volunteer organizations that supported young people. Mirroring the times, there were few known sports organizations for girls. Baseball, ice-skating, swimming, and playing in the streets were the norm for most children who grew up in Prospect Park. Volunteers coached and managed sports teams; youth baseball was supported by "passing the hat." The borough, because of its intimacy and religious foundation, sustained its spirit during wartime, exemplified by those who served and those who gave their lives.

There was, and still is, one public school in the borough, Prospect Park School No. 1. The school, which has been and continues to be the center of the community, has retained its original facade, built in the 1920s. The school bell, rung by hand by the custodian, summons children to classes each day. As a community center, the school was also a place for activities for children and their families. Many families chose to send their children to religious schools rather than the public schools. As the borough matured, the Catholic school, St. Paul's, closed due to low enrollment, and Eastern Academy, a Christian school, moved to neighboring North Haledon. Reflecting the emergent diversity of the borough, Al-Hikmah, an Islamic school, is housed in the former Eastern Academy School building. As will be shown in this book, it is the public school that mirrors the diversity of the borough.

Prospect Park remains a borough of small businesses, though the nature of the businesses has changed. Paterson is no longer the industrial magnet for craftsmen and mill workers. The small textile shops that were in Prospect Park have closed and moved to other locations. Most of the first- and second-generation Holland Dutch have either passed on or have moved to neighboring towns, though some continue to live and remain active in community life. The Christian churches have either consolidated or have moved to neighboring towns. The blue laws remain for the business community, though residents are not restricted from play and home improvement on Sunday. In the coming chapters, the reader will find a Prospect Park that has evolved from suburban to urban-suburban. The houses remain two- and three-story structures; North Eighth Street and Haledon Avenue are small-business hubs; and, rather than Dutch being spoken, English, Spanish, and Arabic can be heard on the street. This book chronicles how communities struggle to preserve the past and at the same time make way for change.

One

DUTCH HILLS
BY EMAN AL-JAYEH

What is now Prospect Park was hunting and camping grounds of the Lenni Lenape tribe, who were native to much of New Jersey. The Westervelt and Ryerson families purchased land from the Native Americans and transformed the woodsy area into cultivated farms. Over the years, this plot of land was used for various purposes, and it has historical significance. Looking out at North Eighth Street, one can envision George Washington riding on his horse as he crossed what was once Cannonball Road during the Revolutionary War. Washington, it was reported, visited the Dey Mansion in Wayne in the year 1780. He noted his observation of the area in his diary.

When a group of immigrants from the Netherlands settled in Prospect Park, the men and women decided to model the town on their own ideals. The settlers valued church and home life above all. They maintained their culture, and the Dutch language was spoken by the majority of the residents. All borough council meetings had minutes recorded in Dutch. The faithful observance of customs and ordinances distinguished the borough from other American communities at the time. Prospect Park was nicknamed "Little Holland," after the group of Hollanders who established a colony along the sides of what is now East Main Street in Paterson.

The pioneers' vision of a close-knit community resulted in the creation of the Borough of Prospect Park on March 13, 1901. The sale and consumption of alcohol was prohibited, making it a dry town, which helped create a family-friendly borough. Prospect Park was built on a foundation of religion, family, and volunteerism.

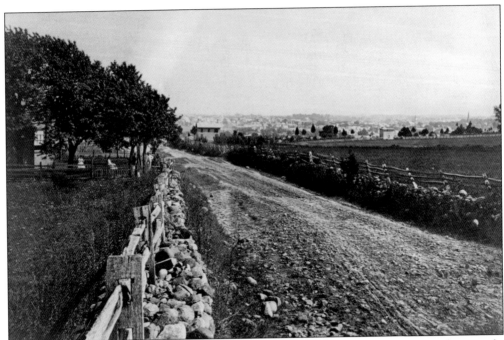

The above photograph is a view toward Paterson overlook in the late 1800s. The photograph, with a view looking south toward Paterson, was taken at present-day Haledon Avenue. The below photograph, taken in the 1850s, shows the Hopper homestead at Haledon Avenue and North Eighth Street. The Hoppers were one of the first families to establish a home and farm in the region. What is now part of Haledon Avenue is thought to have been be part of Cannonball Road, which had a prominent role in the Revolutionary War. George Washington was reported to have visited the area on two occasions in 1780 or 1781.

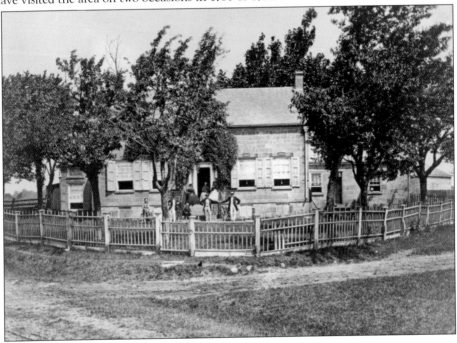

The Planten Homestead was another large estate. Much of Prospect Park is part of the former Planten, Hopper, and Westervelt estates. The Planten family played a prominent role in the development of Prospect Park. As a tribute to the Planten family, Prospect Park named one of the main streets Planten Avenue.

Pictured is Adrian Struyk, who was the first mayor of Prospect Park. It is said that the borough borrowed money from him to cover bills since it was short on cash in the early years. The first borough hall was in Mayor Struyk's basement. Council meetings also took place in the school and in private homes throughout the borough. Townspeople were known to sit on the carpeted floors of private homes, which suggests the meetings—where decisions were made for the well-being of the borough—were informal. This is where meetings took place, and because of his significant contributions to the foundation and development of Prospect Park, a street is named in his honor that runs parallel to Planten Avenue.

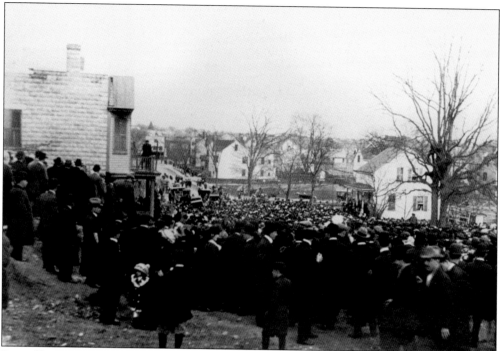

Botto House in Haledon is seen on the left in this photograph. The Botto House had a role in the Paterson Silk Strike of 1913. Speakers stood on the second-floor balcony and gave rousing speeches to strikers who came to Haledon. The speeches made at the Botto House were given in the language of the workers, which included Dutch, Russian, and Italian. Visible in the distance is Prospect Park. The borough had a limited role in the Paterson Silk Strike. (Courtesy of the American Labor Museum/Botto House National Landmark.)

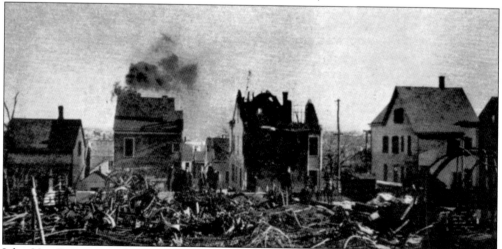

John Van Buiten was the factory owner and fire chief of Prospect Park in the winter of 1918, when the fire departments of Prospect Park, Haledon, and Paterson battled a fire at the Century Woven Label Company Mills in Prospect Park. The lack of water frustrated the efforts of the firefighters, and the mill burned to the ground. The damage was estimated at $15,000, not including the machinery and goods. A number of houses were destroyed as well. The cause of the fire is unknown, but it started in the basement.

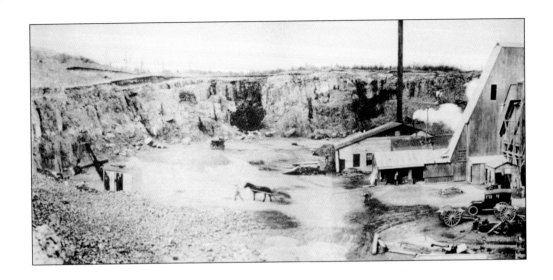

The Prospect Park Quarry, located next to the Hayfields, was opened in 1901 by James Sowerbutt. Ownership passed to Abraham Vandermade in 1916. Owners of the quarry mined shale, sold and used for road construction, mainly for roadbeds. In 1969, the Warren brothers acquired the quarry, which operated until the 1980s. Later, Tilcon Corporation purchased and operated the quarry for 20 years. As of 2010, the quarry was closed. Prospect Park took ownership of the quarry in July 2012. Above, a horse is shown pulling machinery used to mine shale. Shown below is a sample of quartz found at the quarry. The quartz was colorful and considered a collector's item.

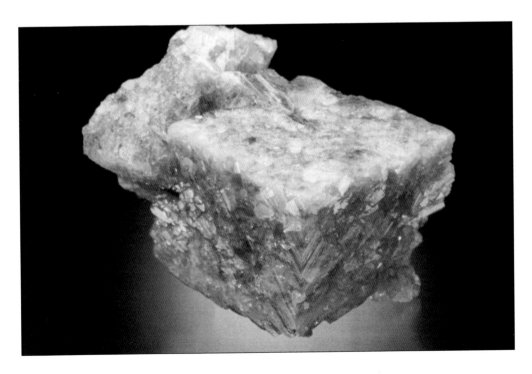

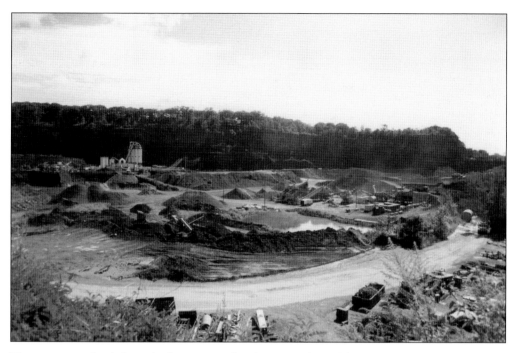

The quarry evolved through the years under the ownership of different corporations. In these photographs, the changes can be seen from its earlier years under James Sowerbutt. The technology also evolved, from the horse-drawn equipment of early days to modern mining equipment used in later years. Over 60 different species of minerals have been found in the quarry. Mineral specimens from the Prospect Park Quarry are on display in the Smithsonian, the American Museum of Natural History, and in a nearby Paterson museum.

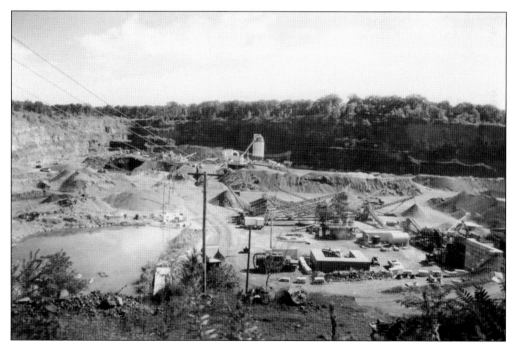

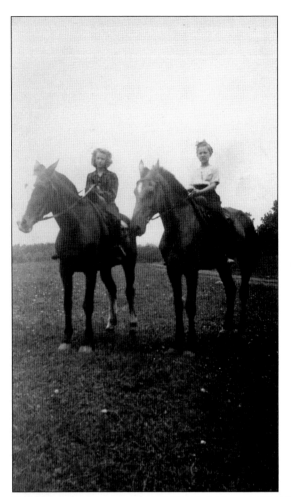

The Hayfields were located on a hill in the northeast section of the borough. There were 22 acres of woodland situated at the end of what is now the Struyk Avenue Extension. The Hayfields were picnic grounds, places for horseback riding, and an open field for recreation. For many families, the Hayfields were a pleasant escape to a more rural and woodsy location. Pictured at left are two childhood friends, Carol Memoli (left) and Joan Matthews, enjoying horseback riding. Below, Memoli (left) and Matthews pose with their horses. (Both, courtesy of Carol Memoli Lamela.)

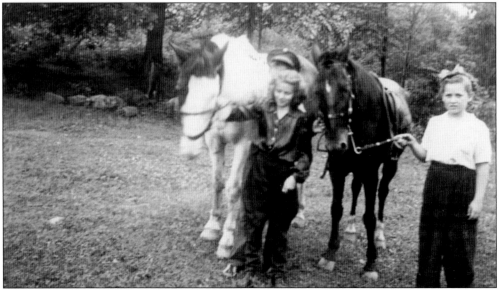

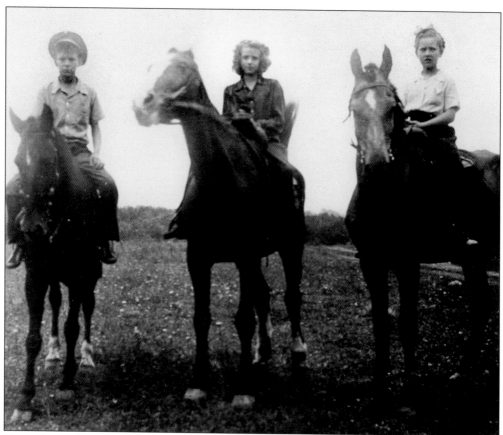

Here, three young people enjoy a day of horseback riding in the Hayfields. Pictured from left to right are an unidentified boy, Carol Memoli, and Joan Matthews. The open fields of the Hayfields are visible behind the children. The fresh air and open space were refreshing for children and adults alike. (Courtesy of Carol Memoli Lamela.)

Children, like Carol Memoli (pictured), usually accompanied by a parent, walked up the hill to a nearby stable and rented a horse for a nominal fee. When the horseback ride was complete, many of the children and their families would picnic and look for quartz stones scattered about the Hayfields. To the delight of some, the completion of a wonderful day in the Hayfields included returning home with a precious stone. (Courtesy of Carol Memoli Lamela.)

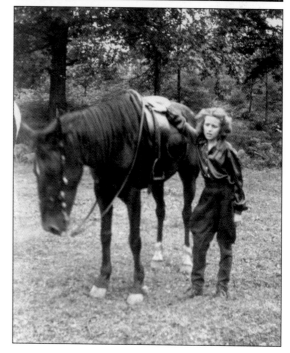

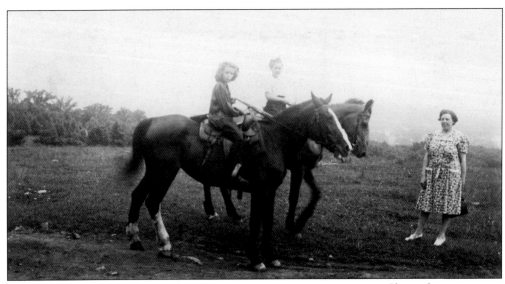

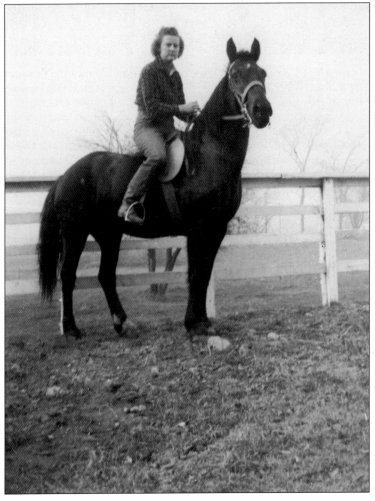

Shown here on horseback are Carol Memoli (left) and Joan Matthews. Joan did not live in Prospect Park, but she was a good friend of Carol's. Also shown here is Carol's aunt, Jean Benedict, who lived on Fourteenth Street. Beyond the horse riders is an early, although blurred, view of the New York skyline. (Courtesy of Carol Memoli Lamela.)

Local resident Doris Steinga rides her own horse. The Steinga family owned a grocery store on the corner of Tenth Street and Planten Avenue. (Courtesy of Carol Memoli Lamela.)

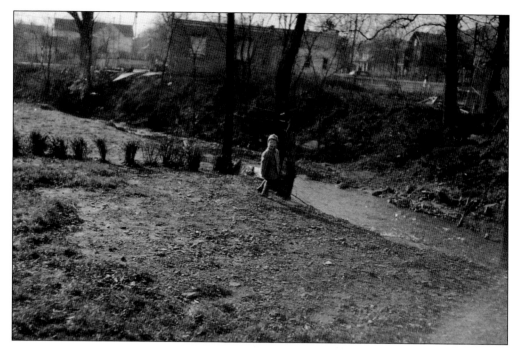

The Molly Ann Brook, also called Molly Ann's Brook, flows through Passaic County and Prospect Park before emptying into the Passaic River. In the early 20th century, Molly Ann Brook became well known in the region for overflowing its shallow banks. In 1945, a historic and massive flood affected the towns along the brook, particularly Prospect Park. Many homes were severely damaged. In the mid-1950s, a flood-control project widened the brook area and reinforced the banks. The above photograph, taken in the 1930s, shows a young child standing by the banks of the brook prior to its reconstruction. Here, the banks of the brook are low and thus prone to flooding. Below, Molly Ann Brook flows from North Haledon and by Manchester Regional High School as it gains momentum on its way to Prospect Park.

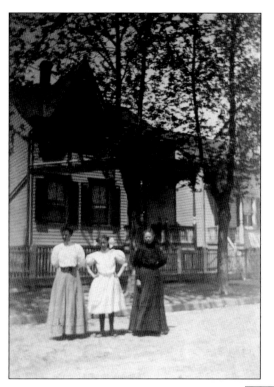

Women of an undetermined age stand in front of one of the original Prospect Park homes on North Seventh Street. Note the dress of the time, which included long skirts for women and shorter skirts for girls. These women, reported to be sisters, are standing in front of the house that their father built on the dirt road.

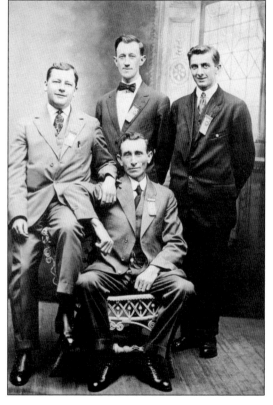

Here, four gentlemen of the town pose for a photographer. Note how they are dressed in their Sunday finery. The man standing at center wears a bow tie, and the others wear the traditional neckties. In addition, the man with the bow tie is the only one not wearing a vest underneath his jacket. Vests were considered a necessary fashion accessory of the times. Note also the highly polished shoes, as if one could see one's face in the shine.

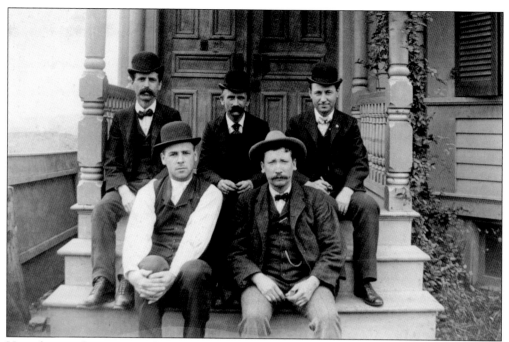

Here, five gentlemen sit on the front stoop of the Hopper house in the late 1910s or early 1920s. The men in the rear are wearing the traditional bowler hat. Many photographs of the time were taken on front stoops. In a small town like Prospect Park, the fronts of houses were gathering places. (Courtesy of Joan M. Burrows.)

Neighborhood children play in front of a stoop with shovels, indicating that they are having a good time playing in the dirt. The photograph may have been taken in the fall or winter, as the children are bundled up to stay warm. Growing up in Prospect Park meant playing outside in front of the house and on the sidewalks with neighbors. That is what made the community and neighborhoods tightly knit.

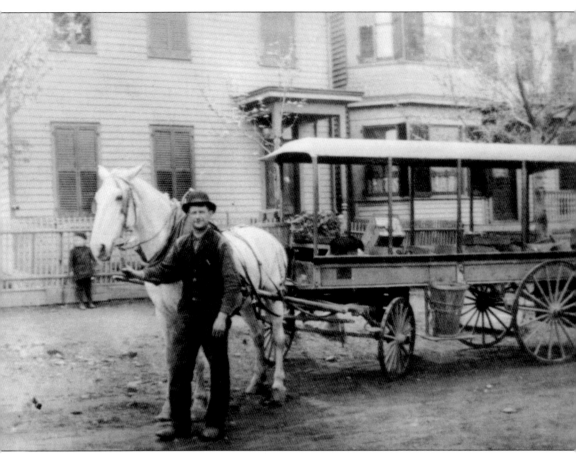

John Tanis was born in 1874 in Holland and immigrated to the United States and resided within the borough of Prospect Park. He was married with four children. It is thought that Tanis, pictured here with his horse and wagon sometime in the early 1900s, later became a merchant.

Shown here is a butcher's wagon. It was common in the period for merchants to take their goods on the road, out of their store. Butchers selling meat and vendors selling produce and flowers were regular visitors to the streets of Prospect Park.

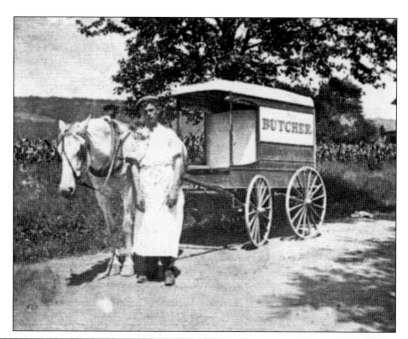

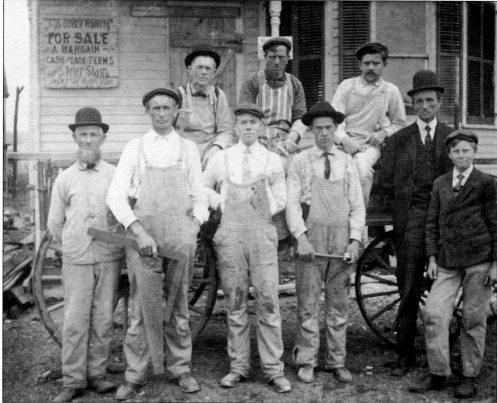

Here, workingmen pose in an undated photograph. Several are dressed in overalls, and their clothing underneath can be seen. Some wear a white shirt and tie; others wear a dress shirt. The men on the right are presumed to be merchants. (Courtesy of Joan M. Burrows.)

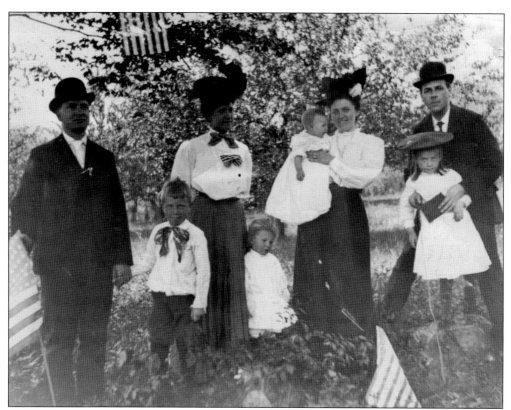

The Boers were a prominent family in Prospect Park. Pictured above are Mr. and Mrs. Boer and their children, apparently celebrating a Fourth of July or a Decoration Day holiday. During this period, apparently the early 1900s, the Fourth of July was a festive holiday. Note the ornate hats the women are wearing. The boy wears knickers and a big bow, and the girls are dressed in white. The older girl on the right wears a rather interesting hat. In the below photograph, Henry Boer is the third boy from the right. The children look to be around seven to ten years old. It was common for children to gather in the open spaces of the borough prior to the building boom that took place in the 1920s. (Both, courtesy of Joan M. Burrows.)

The artifact to the right is a letter from the State of New Jersey to George J. Popp, informing him that he has been selected for military service, commonly known as the draft. The date on the draft notice is May 18, 1917, which is about a month and a half after the United States entered World War I. Popp was directed to "report for military service in person or by mail or telegraph." Popp and many others proudly served their country in World War I and future wars and conflicts. George Popp is shown below in his World War I uniform. Not visible are the clogs or Dutch shoes that Popp is wearing. (Both, courtesy of Joan M. Burrows.)

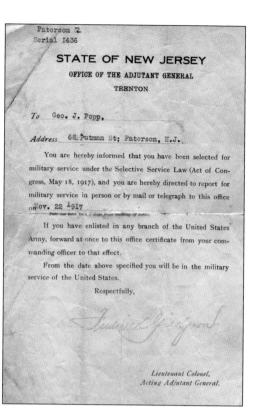

Paterson 2
Serial 1436

STATE OF NEW JERSEY

OFFICE OF THE ADJUTANT GENERAL

TRENTON

To Geo. J. Popp,

Address 68 Putman St; Paterson, N.J.

You are hereby informed that you have been selected for military service under the Selective Service Law (Act of Congress, May 18, 1917), and you are hereby directed to report for military service in person or by mail or telegraph to this office on Nov. 22 1917.

If you have enlisted in any branch of the United States Army, forward at once to this office certificate from your commanding officer to that effect.

From the date above specified you will be in the military service of the United States.

Respectfully,

Lieutenant Colonel,
Acting Adjutant General.

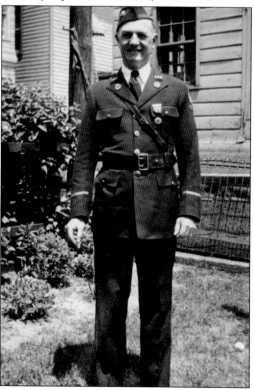

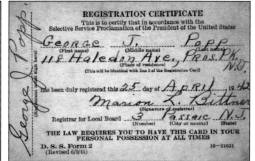

Shown at top is what is known as a Citizens' Defense Corps identification card. During World War II, the civilian population in communities across the country assumed the role of homeland defense by keeping their eyes and ears open for fifth-column activity. Some were sky watchers, looking out for enemy aircraft. Others were wardens that assisted in blackouts during air-raid drills. The Citizens' Defense Corps was an important part of the nation's defense during World War II. The middle image is George J. Popp's World War II draft card. Note that Popp was a resident of Prospect Park and lived on Haledon Avenue. According to family history, Popp served in World War I. Shown below is the Prospect Park American Legion Memorial Post 420, affectionately known as the "Wooden Shoe Post." Note the orange helmets, wooden clogs, and wooden canes. Prospect Park has always demonstrated pride in its veterans and, in particular, the Wooden Shoe Post. (All, courtesy of Joan M. Burrows.)

Two

CORNERSTONE OF
A COMMUNITY
BY PAIGE RAINVILLE

For the early settlers of Prospect Park, ethnicity and faith were deeply intertwined. An adherence to the Christian religion was not just a personal part of individuals' lives, but a common thread for the whole community. The borough was built upon the foundation of Christian faith as an attempt to maintain the cultural values of the founders' Dutch heritage. The values of community, church, and a quiet home life permeated the borough, as evidenced by members' commitment to church attendance, private education, and keeping the Sabbath. Early residents of the borough reminisce of twice-a-day church attendance on Sundays, which was encouraged by the Sunday blue laws. These laws followed a borough-wide Sunday observance. No commercial activity or any form of work was permitted, including, as one resident clearly remembers, the hanging of laundry to dry. With no allowance for extra activities on Sundays, church attendance flourished. Churches within the borough limits included Prospect Park Christian Reformed Church, Bethany Reformed Church, and St. Paul's Roman Catholic Church. Second Christian Reformed Church and the Ebenezer Netherlands Reformed Church, located nearby in Paterson, also had many members who resided in Prospect Park.

Along with church attendance, Christian education was seen as a necessity for many residents. Approximately half of the students in the borough attended private or parochial schools throughout the first half of the 20th century. Notably, the Eastern Christian School Association, founded in 1892 and consolidated into one organization in the 1950s, educated many Prospect Park residents through the years. Funding for the schools was often supported by residents of Prospect Park. During times of financial strife, the community served as a beacon of hope, with Young Ladies Societies in churches hosting fundraising bazaars and individuals offering to make personal sacrifices to keep the schools going. In 1924, the association's secondary education school, Eastern Academy, was established on North Eighth Street in Prospect Park. Enrollment was high, and an addition was added in 1928 to accommodate the growing number of students.

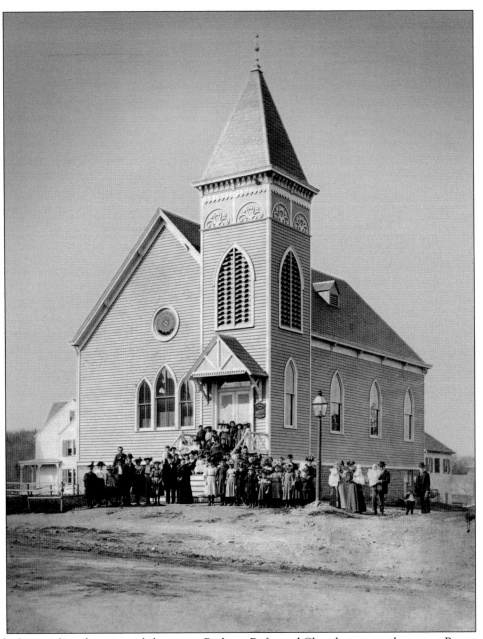

The house of worship currently known as Bethany Reformed Church was once known as Prospect Park Baptist Church. One may struggle to recognize the church in its appearance today. With an addition to the front of the church and the erection of homes and businesses in the vicinity, the building now takes on a different appearance than that shown here. The structure seen here, set apart from other buildings and located on a quiet dirt road, today occupies a place on a thriving and busy thoroughfare bustling with activity. The foundation of faith for the borough of Prospect Park predates paved roads. The children and adults in this photograph illustrate churchgoing as a family affair. Everyone is in his or her Sunday best: the women in dresses and headwear, and the men in suits and ties. Even the children are dressed up for the weekly event of church attendance. (Courtesy of the Passaic County Historical Society, Paterson, New Jersey.)

The addition to Bethany Church that took place in the 1950s is not the only change that occurred to the structure once known as Prospect Park Baptist Church. The church would soon become Bethany Reformed Church.

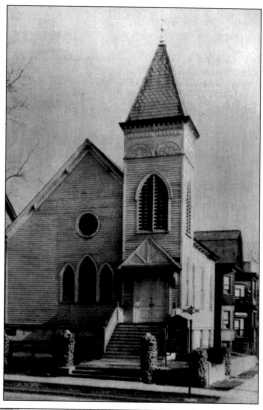

Pictured in front of the Bethany Reformed Church are members of the Verblaauw family. Tunis Verblaauw (second row, left) was the president of the Prospect Park Board of Education for many years. The Verblaauw family played a prominent role in the economic development of the borough with their hardware store. They were members of the Ebenezer Church, located on Haledon Avenue in Paterson, although here they appear in front of Bethany Reformed Church.

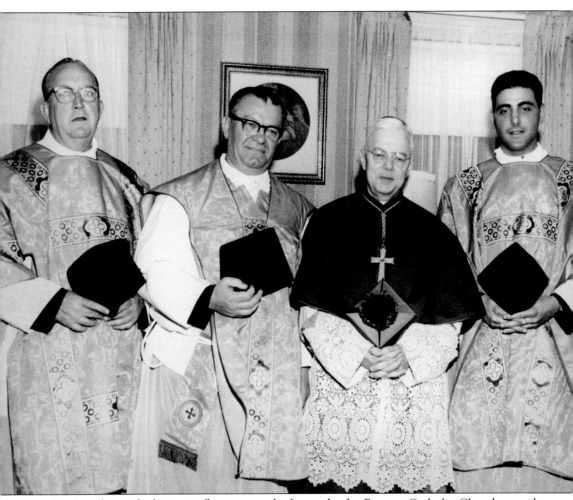

In the sphere of religious influences on the borough, the Roman Catholic Church was also a presence, although to a lesser degree. On July 25, 1925, St. Paul's Roman Catholic Church on Haledon Avenue was incorporated as a parish to serve Catholics in Prospect Park and its neighboring towns. Father Zawistowski (second from left), better known as Father Stanley, was the third pastor to serve the parishioners of St. Paul's. He took the church from a wooden structure to the beautiful building that stands today. From 1952 until 1971, Father Stanley faithfully served the church, and under his leadership, the convent, St. Paul's School, the church, and the rectory were all constructed. He is remembered by community members for hosting fantastic picnics and events. In the 1960s, it is said, the church held a New Years party, in which a 50/50 raffle took place. Since Prospect Park prohibited gambling, the results were made known across the street, in the borough of Haledon. Father Stanley served the church until he passed away, leaving his parishioners with a legacy of hard work and passion, beautifully encompassed in the architecture of the church that stands today. (Courtesy of the Passaic County Historical Society, Paterson, New Jersey.)

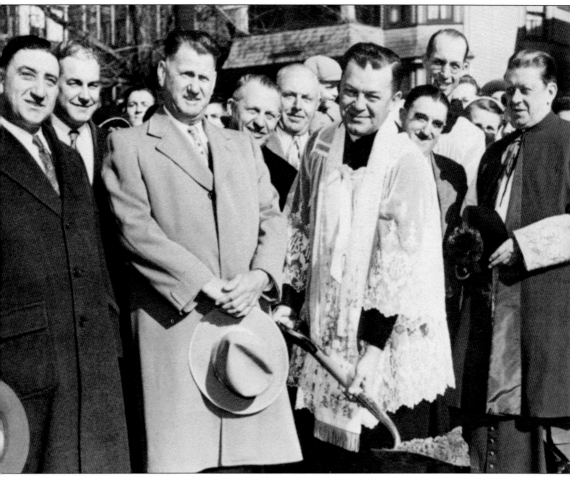

The ground breaking for the new school, on April 3, 1954, was a community event. Clergy and parishioners alike took part in the ceremonies, as did community members, like Mayor Daniel Hook (second from left). Father Stanley holds the shovel that began the task. Former pastor of St. Paul's, Monsignor O'Sullivan, who had been called to serve elsewhere after years of faithful service, stands at right, watching the long-awaited moment finally come to pass. The road to this day was a difficult one, as raising money for the school was no easy task. Father Stanley had been given a mandate by Archbishop Thomas A. Boland: "Start a school." Supported by his parishioners, Father Stanley was able to raise the funds needed to begin and finish the school and to erect other church buildings as well. (Courtesy of St. Paul's Roman Catholic Church.)

Vincent Parrillo, a resident of neighboring Haledon, was president of the Holy Name Society of St. Paul's Roman Catholic Church at the time of this photograph. The Holy Name Society was a men's society that was very active at St. Paul's. Each year, the society would parade up Haledon Avenue through Prospect Park, marching to music. Parrillo was the grand marshal in one of these parades. It is reported that the Christian churches rang their bells as the men marched down Haledon Avenue. (Courtesy of the Passaic County Historical Society, Paterson, New Jersey.)

Another important member of St. Paul's is Msgr. Edward Kurtyka, pictured here at right with a visiting minister. Monsignor Kurtyka has served St. Paul's Roman Catholic Church for many years in several different positions. He now serves as pastor of the parish.

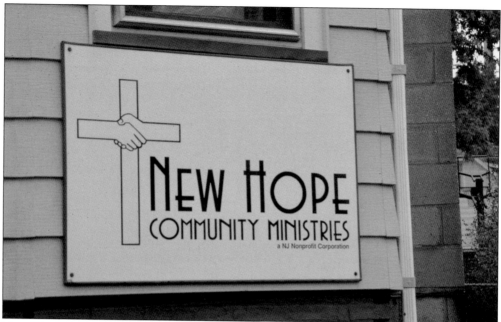

New Hope Community Ministries, located next to Unity Christian Reformed Church, is a nonprofit, freestanding organization that serves residents of Prospect Park today. The ministry offers a variety of services to the community, including a food pantry that serves eligible applicants on a monthly basis. New Hope also partners with several local churches to provide ESL classes, after-school tutoring, and community immigration clinics. Mentoring and family programs are also at the core of New Hope, looking to empower community members through providing physical, relational, and emotional support. Overall, New Hope remains as an integral part of the Prospect Park community, lending aid to those who need it in a variety of forms. (Courtesy of Rita M. Vander Stad.)

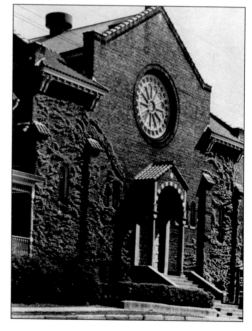

The Prospect Park Christian Reformed Church had a significant role in the Prospect Park community. This photograph depicts the ivy creeping up the facade of the church, pointing to a prominent stained-glass window that remains there to this day. Although no longer the Prospect Park Christian Reformed Church, this house of worship is still active in the community, as a Spanish-speaking reformed church, The Good Shepherd, or El Buen Pastor. Prospect Park Christian Reformed Church combined with Second Reformed Church of Paterson to create Unity Church in the 1980s.

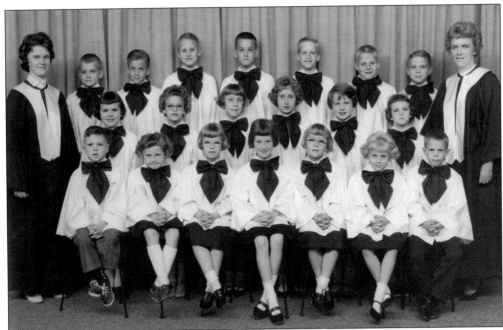

The children's church choirs pictured on this page are believed to be from Prospect Park Christian Reformed Church, which later combined with Second Reformed Church of Paterson to form Unity Church. The above photograph depicts boys and girls with traditional choir bows and choral directors in choir robes. The children's choirs were part of a larger church music program. Shown below is an expanded church choir of the Prospect Park Christian Reformed Church in 1962. At upper left are the pipes of the traditional church organ, used to accompany soloists and choral groups. (Both, courtesy of the Passaic County Historical Society, Paterson, New Jersey.)

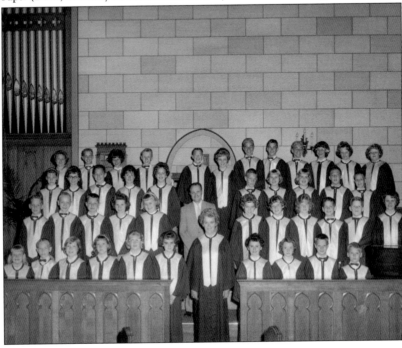

Unity Christian Reformed Church was formed in 1986 by the merging of Prospect Park Christian Reformed Church and Second Reformed Church of Paterson. These churches, formed in the late 1800s, suffered from declining memberships in the 1970s and 1980s. They merged on January 5, 1986, in order to better serve the Prospect Park community. Several pastors have led the congregation since then, including Rev. Paul De Vries, Rev. Joe Vugteveen, Rev. Clair Vander Neut, and Rev. Brian Bolkema. New Hope Ministries, located next door to the church, has been an integral piece of the community. It is supported by Unity Church, although New Hope is a freestanding ministry that looks to the support of other local churches in Northern New Jersey.

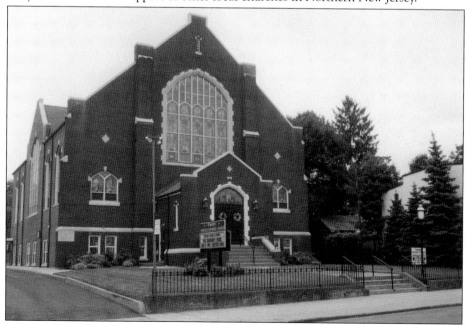

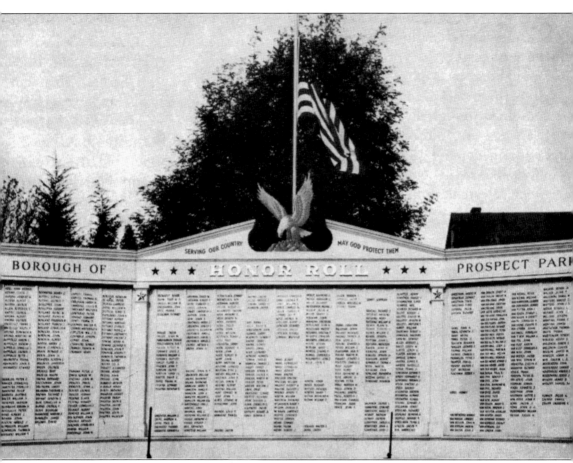

The Honor Roll of World War II was erected to honor the men and women of Prospect Park who served their country during a time of war. Wooden slats with the names of those who served could be easily added or removed from the honor roll. It was located in the yard next to the old municipal building, a popular part of town where it was sure to be noticed. The prominent words "May God Protect Them" stood out as a reminder to the people of the borough of their faith in God, even through difficult times. The importance of service is now commemorated in the form of several memorials located in front of Prospect Park School No. 1.

The Christian Burial Fund, founded in 1910, was a local insurance company created for those of the Christian faith who were conscious of the costs of funeral and burial services. The society serviced many members of the Prospect Park community until it dissolved in the mid-1990s. The connection between the church community and Eastern Christian School Association can be seen in Article XIX, which notes that the property of the company would be donated to the association if the society were to close. A close look at this passbook shows that the member faithfully paid her yearly sum of $2.60 to keep her policy current. (Both, courtesy of Joan M. Burrows.)

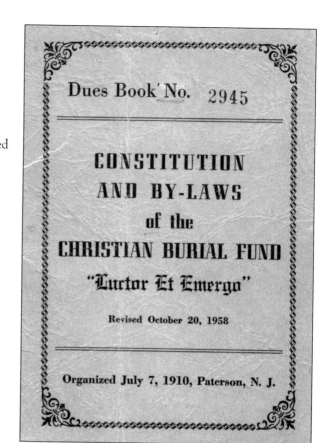

Dues Book' No. 2945

CONSTITUTION
AND BY-LAWS
of the
CHRISTIAN BURIAL FUND

"Luctor Et Emergo"

Revised October 20, 1958

Organized July 7, 1910, Paterson, N. J.

ART. XVIII.

This Society can not be disbanded unless its continuance proves to be impossible, and must be decided upon by two-thirds of the franchised members of the organization.

ART. XIX.

Upon the dissolution of the Society, its property shall be donated to the Eastern Christian School Association of Paterson, New Jersey.

ART. XX.

Voting on matters pertaining to the Society shall be done by acclamation, excepting the election of officers which shall be done by ballot. One half plus one of the votes cast constitute a majority.

ART. XXI.

All work connected with the Society shall be done gratis.

Accepted at the annual meeting held October 20, 1958.

Officers.

PETER ROUKEMA	President
JESS PRUIKSMA	Vice-President
LAMBERT YSKAMP	Secretary
EDWARD FYLSTRA	Treasurer
EDWARD A. NAWYN	Asst. Treasurer
RICHARD TUIT	General Assistant

8

MEMBERSHIP DUES

Date Paid	No. of Weeks	To	Amount	Collector
2/1/59	26 at 08½	1/1/60	2.21	Reg.
8/1/60	52	1/1/61	676	
1-18-61	52	1-1-62	626	R Tuit
1-15-62	52	1-1-63	676	R Tuit
6-14-62	Paid benefit for death of George J. Poppe— June 1, 1962		200	E Fylstra
7-31-63	52	1-1-64	2.60	E Fylstra
3-17-64	52	1-1-65	2.60	E Fylstra
1-28-65	52	1-1-66	2.60	B. N.
1-13-66	52	1-1-67	2.60	B. N.
2-21-67	52	1-1-68	2.60	O.J. N.
1-4-68	52	1-1-69	2.60	C. D.
1-14/69	52	1-1-70	2.60	C D
1/5/70	52	1-1-71	2.60	C D
1/7/71	52	1-1-72	2.60	C D.
1/2/72	52	1-1-73	2.60	C D
1/22/73	52	1-1-74	2.60	C D
12/11/73	52	1-1-75	2.60	C D

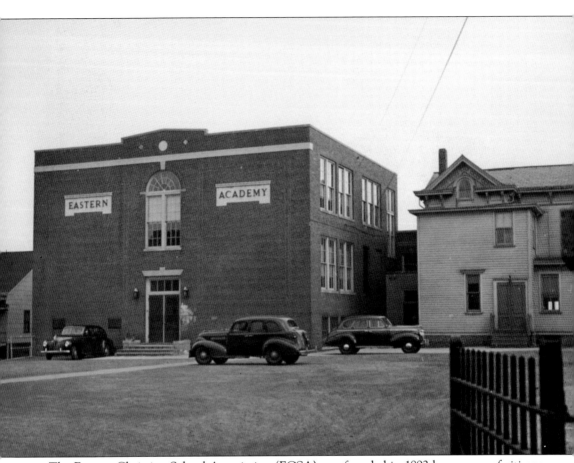

The Eastern Christian School Association (ECSA) was founded in 1892 by a group of citizens dedicated to the Christian education of their children and of future generations. Although Eastern Academy, the high school of the association, was not established until 1924, many residents of Prospect Park attended Christian schools in nearby Paterson, Midland Park, and Passaic. Former principal John R. Bos wrote of the founding of the association in 1932: "And why did they all this. Because we needed a Christian School. Leave out the letter 'a' in the last part of the word Christian and transpose it to read, Christ in a School. That kind of a school we needed." Local sources report that about half of the children in the borough attended private or parochial schools, Eastern Academy included. Financial support for ECSA came from the community of Prospect Park, including donations made by local churches, including Prospect Park Christian Reformed Church, and the hosting of fundraising bazaars by the Young Ladies Society of Prospect Park. (Courtesy of Eastern Christian School Association.)

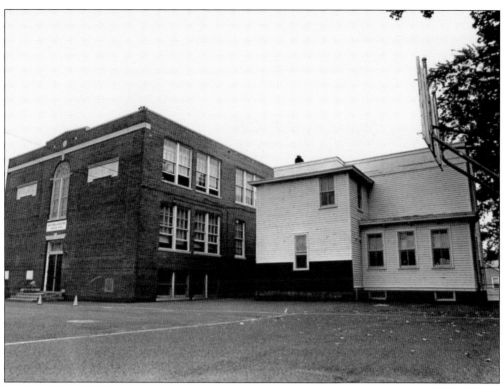

These early photographs show the addition to the school in different eras. The basketball hoop on the far right of the above photograph was used by students as they took part in recreational activities in front of the school. Eastern Academy's years in Prospect Park allowed for residents of the borough who attended the school to have easy access to activities associated with the Eastern Christian School Association. (Both, courtesy of Eastern Christian School Association.)

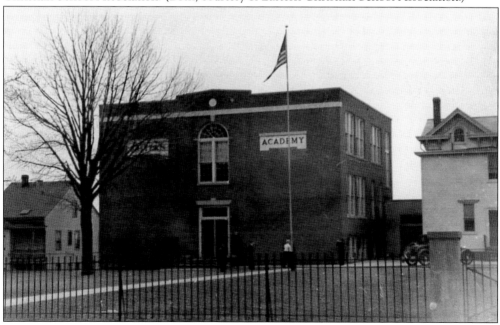

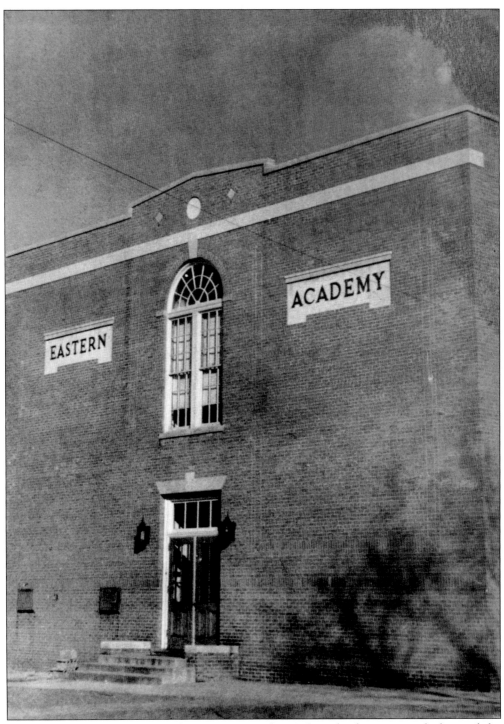

The brick facade of Eastern Academy, as seen in the 1945 yearbook, prominently featured the name of the school. The feet of many students passed over the front stairs, coming to and exiting the academy. Many clubs were photographed sitting on the stairs, indicating that it may have been a popular spot to gather. (Courtesy of Eastern Christian School Association.)

John R. Bos served Eastern Academy of Prospect Park as principal for an impressive span of time, from 1928 to 1943. He led the school through the years of the Great Depression and the start of World War II. His commitment to the Christian faith was evident, as recorded in yearbooks and commencement programs. In the 1939 yearbook, the link between faith, home, and community are wrapped up in his words to the graduating class: "May you ever serve your God faithfully, for then you will also be a blessing to your home and community, to your church and land." (Both, courtesy of Eastern Christian School Association.)

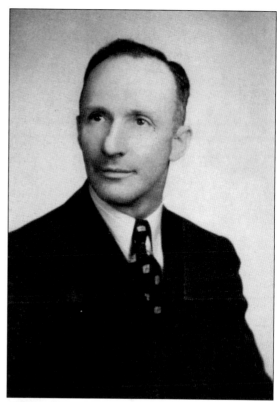

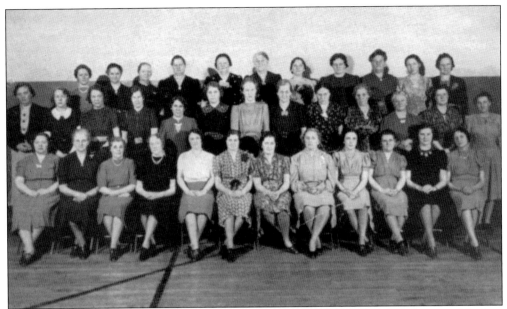

The Eastern Academy Ladies' Circle of Paterson, New Jersey, offered much support and had an active membership of 57 women in 1940. Meetings were held in the Eastern Academy building on alternate Friday evenings, welcoming various speakers on topics from Christian education to health. Although the circle was associated with Paterson, its meetings and many conventions, luncheons, and dinners took place in Prospect Park. The ladies' circle is a clear example of how the Christian community centered on its school. Even the education of the women of this tight-knit community took place through Eastern Academy. (Courtesy of Eastern Christian School Association.)

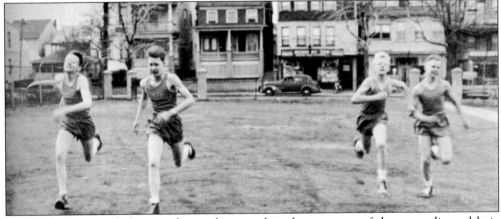

This 1950 photograph features the newly created track team, part of the expanding athletic program at Eastern Academy. The backdrop of this training session is bustling North Eighth Street. The Academy Spa, a popular place for social gatherings, is right of center, at 273 North Eighth Street. The establishment's slogan was "Meet and Eat at the Spa," and customers would stop in for novelties like ice cream and treats. The Academy Spa was not the only small business of Prospect Park that supported Eastern Academy, as evidenced by the many advertisements of local businesses printed in yearbooks. Many owners of these businesses, for example the Verblaauw family of Verblaauw Hardware, also had roles in the churches of the community. (Courtesy of Eastern Christian School Association.)

The steps of Eastern Academy was a popular spot to meet (see page 40). Shown here in 1943 are the school's cheerleaders. Their uniforms reflect the times, with knee-length dresses that had a row of buttons on either side. The captain of the squad (front, center) has the word *captain* hand-sewn into the skirt of her dress. (Courtesy of Eastern Christian School Association.)

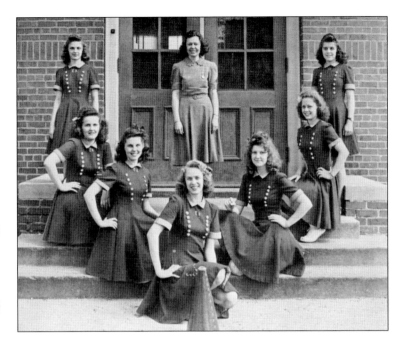

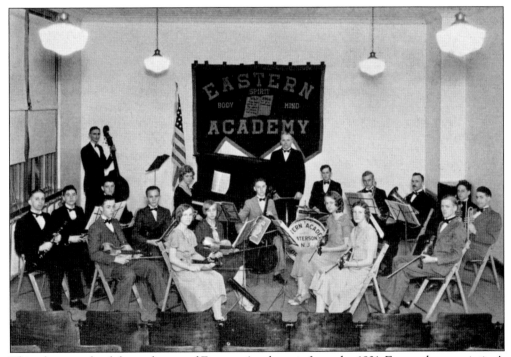

This photograph of the orchestra of Eastern Academy is from the 1931 *Envoy*, the association's newspaper. The young men and women are dressed to the nines. The rows of seats in front of them indicate that this is where concerts for the community were held. (Courtesy of Eastern Christian School Association.)

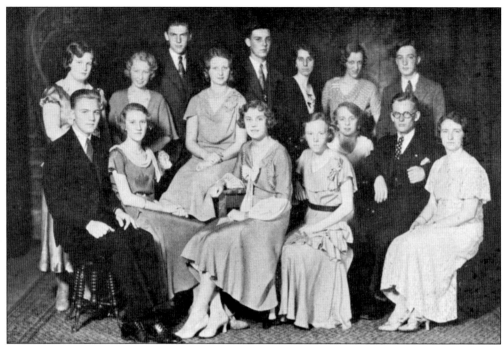

Clubs were an important part of community life at Eastern Academy. The Athletic Association, pictured on the front steps of the school (below), was in charge of promoting athletics. This group, from the 1943 school year, had a successful year. It purchased a variety of sporting equipment, like wall balls, basketballs, and footballs, to use in the schoolyard (where the track team is pictured on page 42). Another popular choice for Eastern Academy students throughout the 1930s and 1940s was the Forum Club (above). The club produced plays in the Prospect Park Public School Auditorium for the community. The photograph shows the 1932 Forum Club. (Both, courtesy of Eastern Christian School Association.)

Among all the clubs of Eastern Academy over the years, one seems to stand out when taking the history of Prospect Park into account. This club could not more clearly relate to what once were the Dutch hills of the borough. The Dutch Culture Club was created in 1945 with the help of a teacher, Mr. Van Til. The goal of the club was for students to connect to Dutch culture, including activities like learning to use everyday phrases in the Dutch language. The group was so large, it had to be divided into two classes! Clearly, heritage was valued, even by high school students at Eastern Academy. Although, due to organization issues, it did not continue, the Dutch Culture Club was an ode to the founders of Prospect Park and Eastern Academy, honoring their impact on the community. (Courtesy of Eastern Christian School Association.)

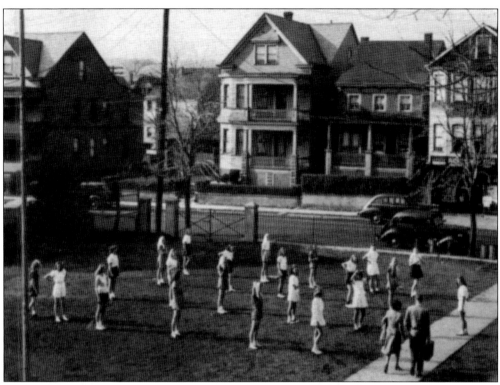

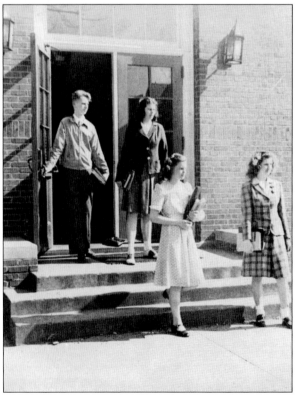

Clubs and extracurricular activities were a vital part of the lives of Eastern Academy students. Their interests varied from academic clubs to sports teams. Pictured here is a group of young women in the yard at Eastern Academy. The students may be taking part in an outdoor gym class, or perhaps holding tryouts for spots on the cheerleading squad. (Courtesy of Eastern Christian School Association.)

Past students of Eastern Academy look back on the school in the same way as the students pictured here, smiling and full of promise. The students of Eastern Academy remember times of strong community ties and unity. Many former residents of Prospect Park reminisce about the prominent hold religion had on the community—from the involvement of local churches to their Christian educations. (Courtesy of Eastern Christian School Association.)

Three

HELPING HANDS
BY MEGAN PERRY

The quiet, family-centered borough of Prospect Park attracted Dutch immigrants with its feel of a "home away from home." The newcomers wanted to live in a community that mirrored their country of origin. The early pioneers of Prospect Park wanted to live, work, and worship in a town that cherished and nurtured the values of family and community they had experienced in the small towns of Holland. Prospect Park was often referred to as "New Holland" or "Little Holland." The early residents brought with them the spirit of service to the community. They made certain that streets were quiet and clean and that Sunday was a day of worship. Residents, usually the men of the town, organized sports teams through churches and civic organizations. There was a willingness to volunteer. While the core values of religion and safe, clean, and quiet streets remain, one can only marvel at the way in which community engagement thrived.

The borough of Prospect Park was an active community. Baseball was the activity that male residents, young and old, played. The small borough was home to multiple baseball teams from different organizations. Boys could belong to one of seven PAL teams, one of four Boys Club teams, or one of three St. Paul's teams. Prospect Park has been home to Girl Scouts, Boy Scouts, and the American Legion, appropriately nicknamed "the Wooden Shoe Post." These groups have volunteered their time and efforts for different functions and events within the community. Families in the early years allowed children to play on the safe streets and sidewalks. Sledding down hills in winter, picnics, horse riding at the Hayfields, and ice-skating on Gaede's Pond in nearby Wayne exemplified the recreational spirit of Prospect Park.

Today, two examples of the spirit of community volunteerism remain: the Prospect Park Hose Company and Fire Company No. 1. Many of the volunteer firefighters are longtime residents of the borough, and some live in neighboring towns. They serve and maintain the tradition of community volunteering in Prospect Park.

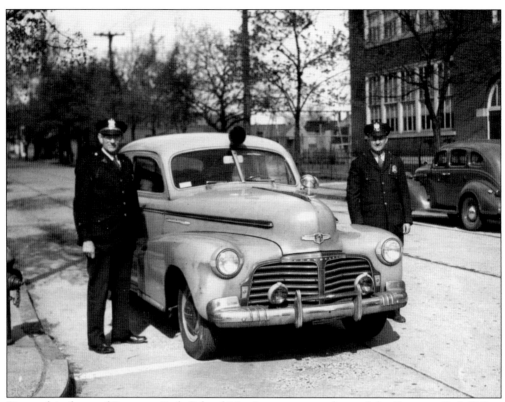

Pictured in front of Prospect Park School No. 1 are two members of the Prospect Park Police Department. They are standing beside their new police vehicle in the 1940s. The department played a prominent role in upholding community blue laws, grounded in Dutch core values, which reinforced church attendance and observance of the Sabbath. The police department enforced the codes that led to the clean, well-kept appearance of the town while emphasizing the importance of sobriety within town limits.

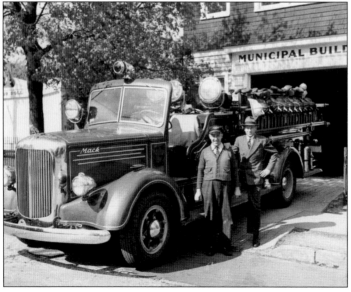

Mayor Ronald Trommelon poses with Prospect Park Volunteer Fire Company No. 1's new Mack fire engine in the 1940s. Prospect Park housed two volunteer fire companies, Company No. 1 and the Prospect Park Hose Company. The companies worked side by side and received assistance from neighboring departments, such as Haledon and Hawthorne, to ensure the availability of resources to extinguish fires.

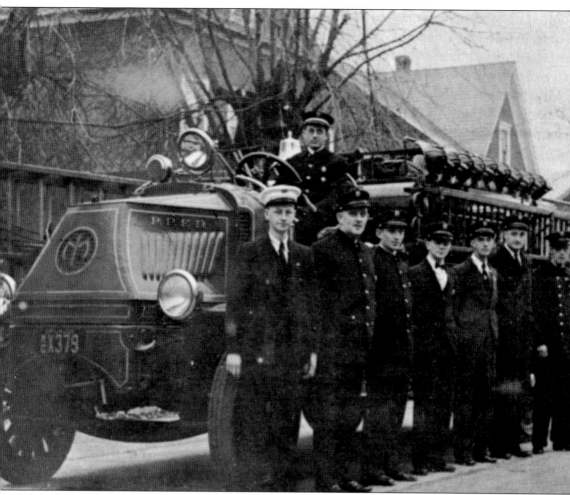

Members of Prospect Park Volunteer Fire Company No. 1 pose in 1934. They are, from left to right, Landus P. Hunt, Roland Redner, August Van Ostenbridge, William A. Cook, Allien N. Hunt, Anthony Ver Hage Sr., Charles Brown, and driver Peter J. Breen. The name change indicates that this photograph appears to have been taken after the split of the original fire company of Prospect Park.

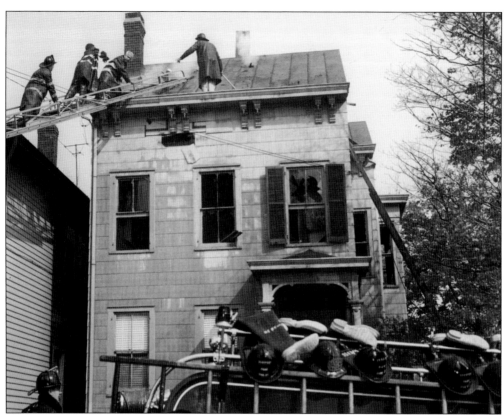

Pictured above is the Prospect Park Fire Department responding to a local fire that required the help of neighboring towns. To save properties from sustaining further damage, it was common for neighboring companies to offer their equipment and services to the Prospect Park Fire Company. The nearby towns of Haledon, North Haledon, Paterson, and Hawthorne would assist the fire company depending on the severity of the emergency. Shown below is Mayor Daniel Hook, standing third from the left and wearing a black fireman's hat, with members of the Prospect Park Fire Department and members of Haledon and North Haledon companies. The assistant fire chief of Prospect Park, the fire chief of North Haledon, and captain and assistant captain from Haledon are among those pictured.

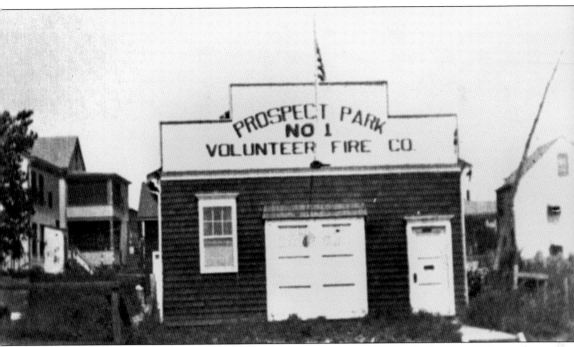

Pictured is the Prospect Park Volunteer Hose Company in 1916. The firehouse was located between present-day Seventh and Eighth Streets on Fairview Avenue. Before the pump was used, four or five firemen were needed to transport and operate the hose to extinguish flames. Due to differences based on policy and religion, the Prospect Park Volunteer Hose Company divided into two separate companies, the Hose Company and Company No. 1, both of which volunteered to maintain Prospect Park's safety.

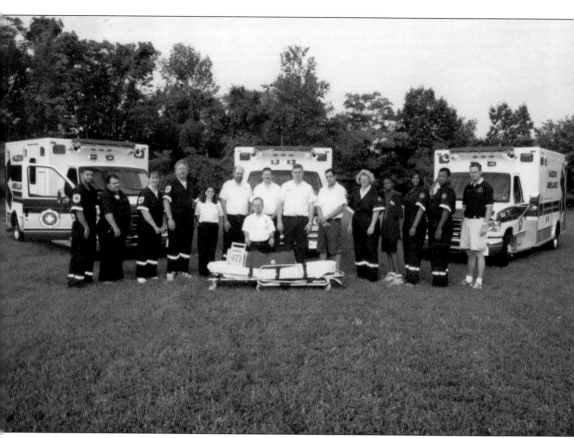

Prospect Park's relationship with neighboring towns is shown by the services offered to each other in times of emergency. Not only did Prospect Park give help, but the borough received help from North Haledon and Haledon. In this photograph, the Haledon Ambulance Corps is shown on the border of Prospect Park and Haledon. The neighboring communities would and still do help each other out in times of emergency. The organization serviced Haledon, North Haledon, and Prospect Park. Haledon Ambulance Corps maintained a location in each town, since the organization serviced all three. Its location in Prospect Park was next to St. Paul's Catholic Church. The ambulance corps was dissolved and became part of North Haledon's. Paterson Fire Department is now used.

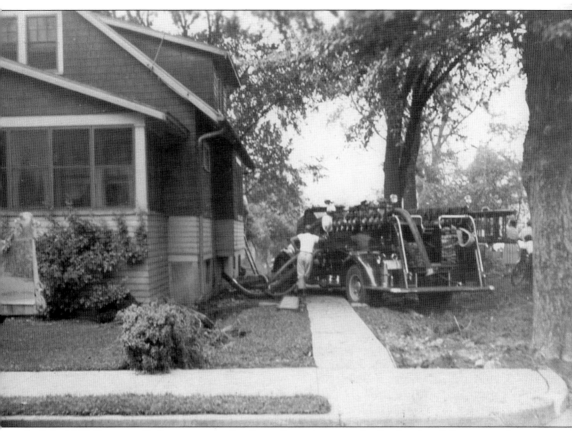

In July 1945, Prospect Park experienced a three-day rainstorm. At the height of the storm, the banks of Molly Ann Brook could not hold back the rushing water, culminating in flash floods through North Fifteenth, Sixteenth, and Seventeenth Streets between Hilton and Fairview Avenues. Molly Ann Brook flowed rapidly and widely over the bridge railing on Calvin Avenue, carrying chicken coops, sheds, and similar materials through the streets of Prospect Park. Here, the fire department assists residents with the cleanup after the flood. Floodwaters had seeped into the cellars of houses, requiring the efforts of the fire department to help get the water out. The cleanup effort took place days after the floodwaters had subsided enough so recovery efforts could proceed.

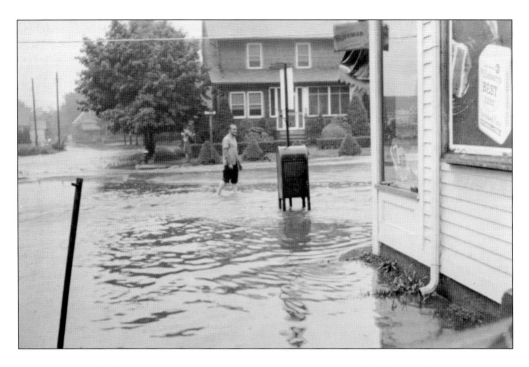

Both photographs shown here demonstrate the destructive waters of Molly Ann Brook during the July 1945 flood. Shown above is a man who is ankle-deep in water, surveying the damage at the corner of Sixteenth Street and Haledon Avenue. Many of the businesses, such as grocery stores, had flooded basements and first levels. In the photograph below, the once peaceful backyard of a Prospect Park resident is turned upside down. Note the fallen tree in the background, the overturned chair, and the height of the brook, which is at flood stage.

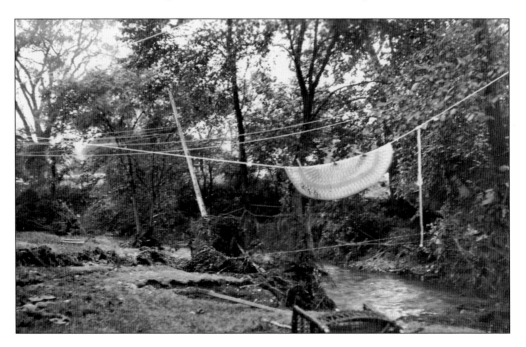

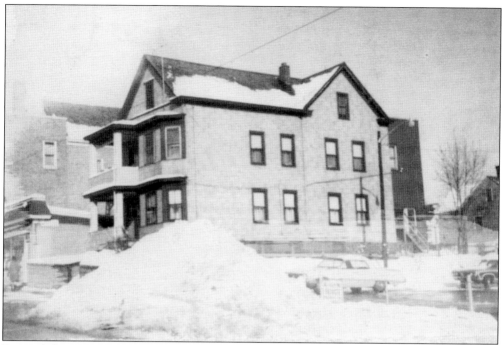

Pictured above is a residence on Seventh Street and Haledon Avenue after a snowstorm. Residents could be seen shoveling the snow dressed in suits and ties, as one longtime citizen of Prospect Park recalls. Neighbors would join the shoveling effort and it would become a community-building event. Shown below are three men from the Prospect Park Department of Public Works (DPW). The department is still active in the community with the upkeep of roads and waterlines. A previous mayor said that the borough did not need a street cleaner because the residents chose to clean the streets themselves. However, as time went on, the DPW assumed a greater role in keeping Prospect Park neat and clean

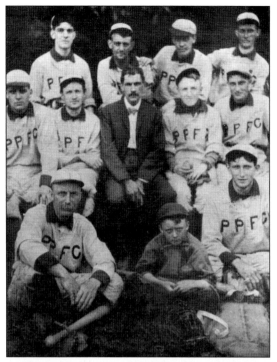

Pictured at left is the Prospect Park Fire Company baseball team of 1904. The Prospect Park Athletic Club baseball team of 1912 is shown below. Baseball was an important recreational activity for the men of the borough. Enjoyment of the sport was passed on to younger generations, as is evident by the abundance of organized teams in the early days. Prospect Park had seven PAL teams, four Boys Club teams, and three teams operated by St. Paul's Roman Catholic Church. Boys could belong to one team or, as some liked to do, play for multiple teams.

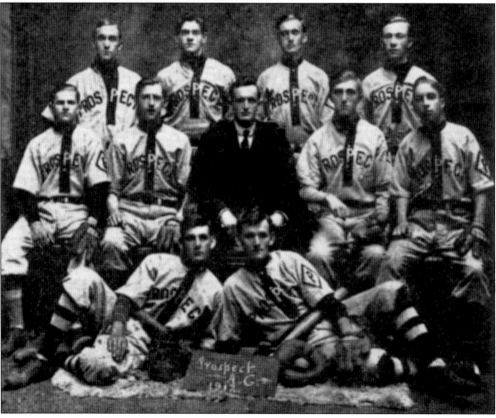

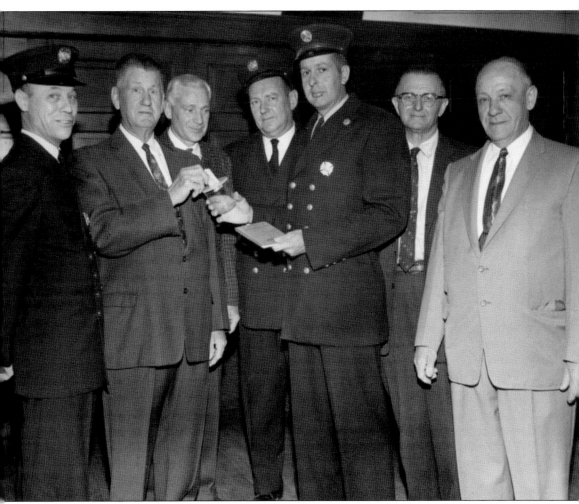

Prospect Park mayor Daniel Hook (second from left) is shown purchasing the first telephone directory for the borough on March 23, 1962. (Courtesy of the Passaic County Historical Society, Paterson, New Jersey.)

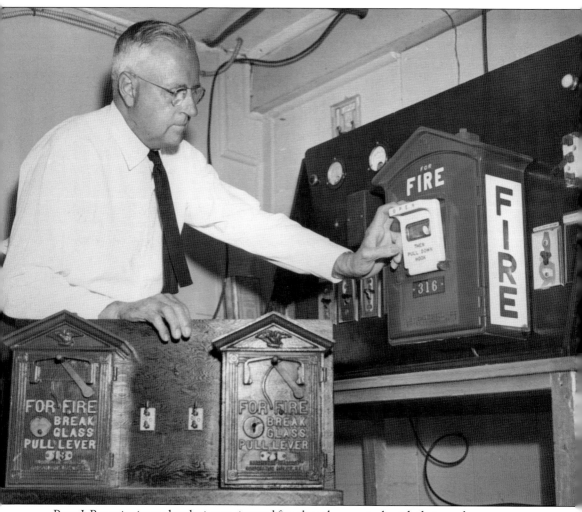

Peter J. Breen is pictured replacing antiquated fire alarm box controls with their modern counterparts on September 29, 1962. The modernization of these controls enabled Prospect Park residents to call for help more efficiently. The old fire boxes had a glass window on the front of the box and in times of emergency the glass needed to be broken and a lever pulled to summon the fire department. The newer boxes had a pull-down lever, advanced technology for the period

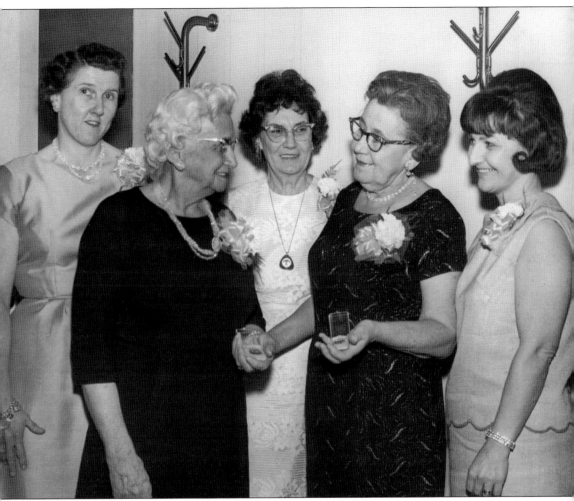

Pictured are five women at the Prospect Park Auxiliary 50th Anniversary gathering on March 13, 1965. The women in the photograph appear to be holding an award, presumably for their service to the fire companies. They served a vital function through fundraising, hospitality, and preparing meals. The women played a critical and important role in supporting firefighters. In addition, women played an auxiliary role for the members of the American Legion. Today, there continues to be a Ladies Auxiliary that supports the fire department. The American Legion auxiliary is not in service.

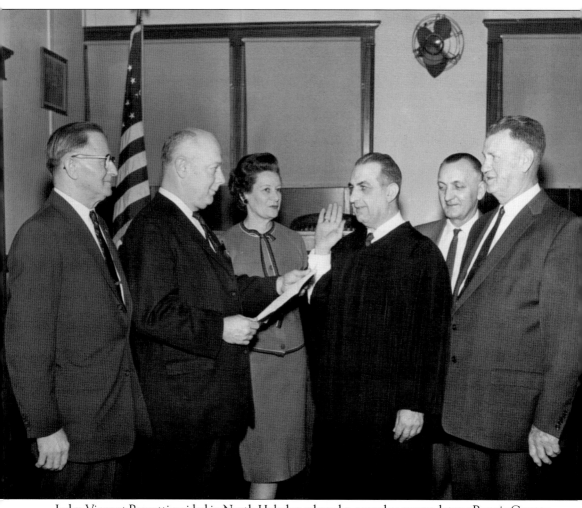

Judge Vincent Pernetti resided in North Haledon where he served as mayor, later a Passaic County freeholder, and a leader of the Republican Party. Judge Pernetti was a magistrate in Prospect Park for many years. Here, he is being sworn in as magistrate of Prospect Park on March 27, 1963, as Mayor Hook (far right) looks on.

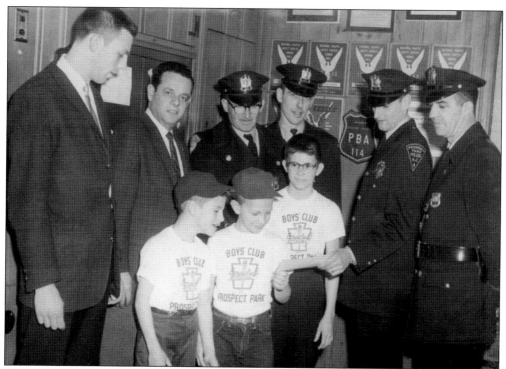

The Boys Club in Prospect Park was a very active organization for youth. The three boys shown here are being awarded. There was a healthy competition between the PAL and the Boys Club, centered on baseball teams. The spirit of competition is celebrated in this photograph, which shows Boys Club officials on the left and Police Athletic League sponsors on the right. The boys eagerly accept what appears to be a contribution. The date of the photograph is unknown. (Courtesy of the Passaic County Historical Society, Paterson, New Jersey.)

While much of the activities provided for youth in Prospect Park were for boys, there was also a thriving Girl Scout troop in the borough. Here, two Girl Scouts have been taught the proper way to fold an American flag. Looking on at right is the troop leader. The man is the post commander of American Legion Memorial Post 240. The man's cap includes insignia representing Dutch shoes, as well as a medal. (Courtesy of the Passaic County Historical Society, Paterson, New Jersey.)

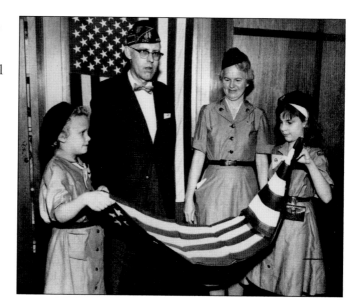

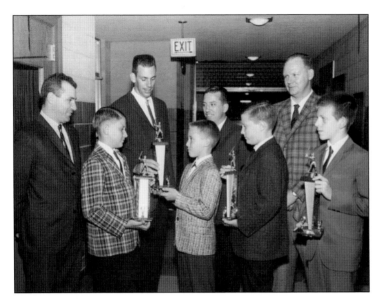

In this September 16, 1965, photograph, four young men proudly receive Boys Club baseball awards for being the most valuable players. Note the formal dress of the boys, including suits, sport jackets, and ties. Community life in the middle and early 1960s meant youth wearing formal attire for community events. (Courtesy of the Passaic County Historical Society, Paterson, New Jersey.)

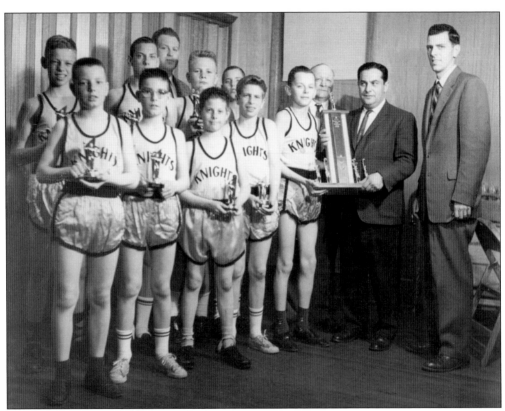

Pictured here on May 22, 1963, are the Prospect Park Golden Knights PAL champs. The boys were awarded individual trophies for their accomplishments, and it is assumed that the unidentified gentleman to the right is awarding a trophy to the team. (Courtesy of the Passaic County Historical Society, Paterson, New Jersey.)

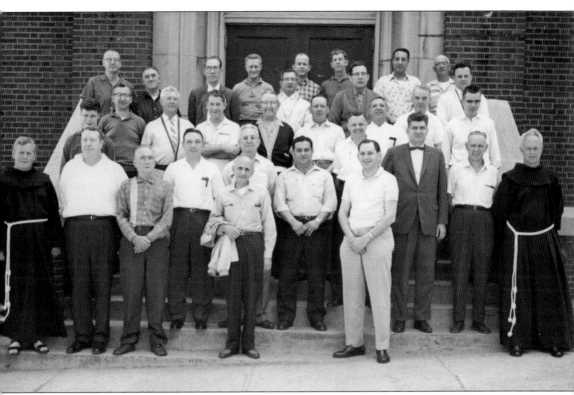

St. Paul's Roman Catholic Church, which is located in the northwest part of Prospect Park, was an active sponsor of many community events. The church sponsored Boy Scout Troop 2. The troop was active within the community. In addition to sponsoring the troop, the church organized retreats for parishioners. The men pictured are unidentified clergy and parishioners on a retreat.

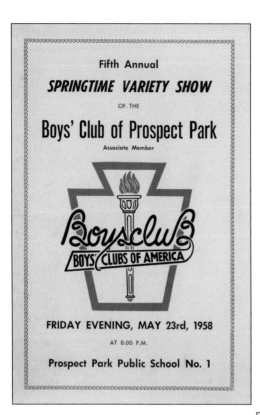

Pictured here are two program covers for the Boys Club springtime variety shows. The activities of the Boys Club of Prospect Park were supported financially by contributions and fundraisers, such as the variety show. The variety show was held in the Prospect Park public school auditorium, before it became the gym. Parents would attend in their Sunday best, and the show was a rousing success, so much so that tickets were hard to come by and the auditorium was standing-room-only. In Prospect Park, fundraising activities for civic organizations were a very important part of community engagement. (Both, courtesy of the Harding family.)

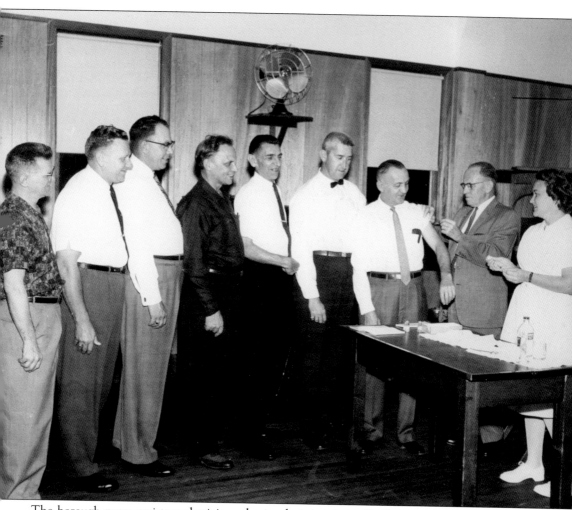

The borough nurse assists a physician who is administering a flu shot to one of the borough councilmen, who also served as the school janitor. Note the absence of air-conditioning; the fan was used to cool the room. The date of the photograph is October 25, 1963. In 1927, there was an outbreak of diphtheria, which soon turned into an epidemic within the borough. There were 46 reported cases in the community, six of which were fatal. The tragic epidemic, brought under control in February 1928, triggered the development of Prospect Park's health program. (Courtesy of the Passaic County Historical Society, Paterson, New Jersey.)

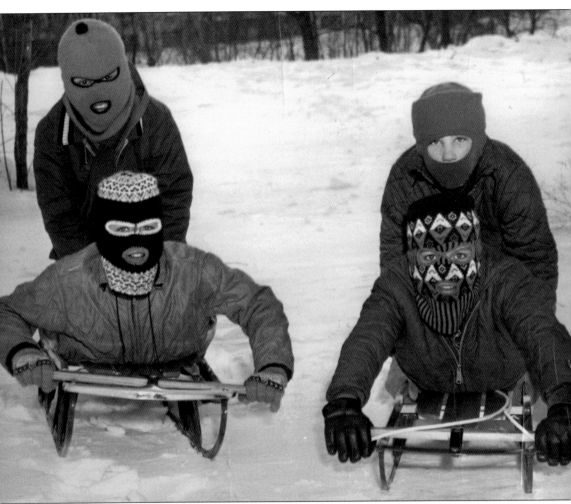

There were many places in Prospect Park and surrounding Haledon and North Haledon to enjoy outdoor sports during the winter. These four boys on Flexible Flyer–type sleds are thought to be on the hill at the rear of Manchester Regional High School, which was the best place for sledding because of its steep slope. Note the ski masks that the boys are wearing. One of the family-friendly features of Prospect Park and surrounding Haledon and North Haledon was the opportunity for children to play outside and enjoy a childhood filled with activities that many recall to this day. Today, many of the fond memories of growing up in Prospect Park are shared and found on social networking sites.

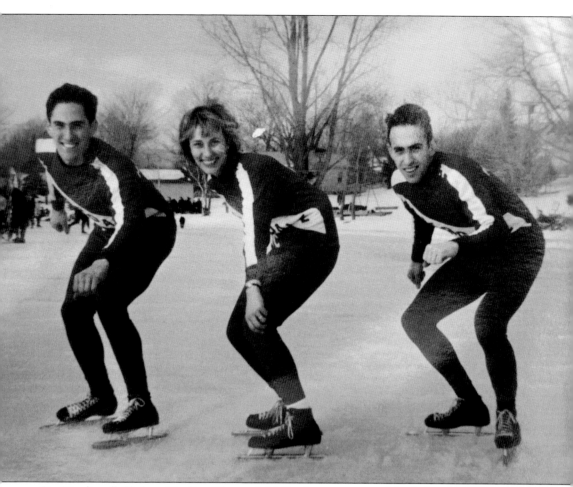

Jim Harding (left), Jean Harding Tier, and Al Harding grew up on North Seventeenth Street in Prospect Park in the family home. They took up speed skating because of their Dutch heritage and the Dutch penchant for ice-skating, particularly speed skating. The Hardings practiced on Gaede's Pond, which is located in nearby Wayne, across from the present-day William Paterson University Campus on Pompton Road. According to Al, in the days when they skated, the pond was much larger, as much of it has been filled in. The Hardings went on to achieve national recognition and fame for their speed skating. This photograph was taken at Greenwood Lake. The National Speed Skating Hall of Fame lists Al in its roster of champions.

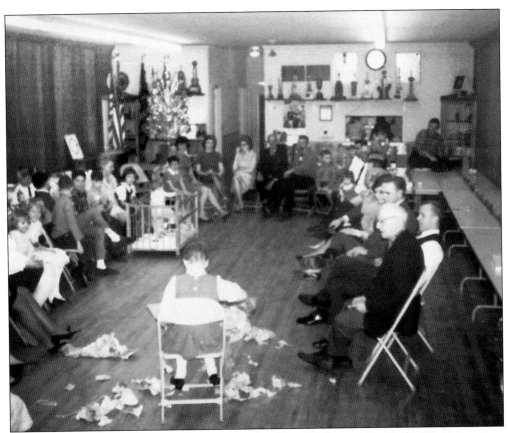

The American Legion hall was located on Eighth Street. In addition to being a meetinghouse for the Legion post, it was a social gathering place for members and families in the community. These photographs show a Christmas party at the post in the 1950s or early 1960s. Note that the event was attended by adults as well as children. The Christmas party was one of the highlights of the year, when children received gifts. The American Legion hall was sold for $1 to the board of education, providing it with space for administrative offices and so as not to lose classroom space. (Both, courtesy of Joan M. Burrows.)

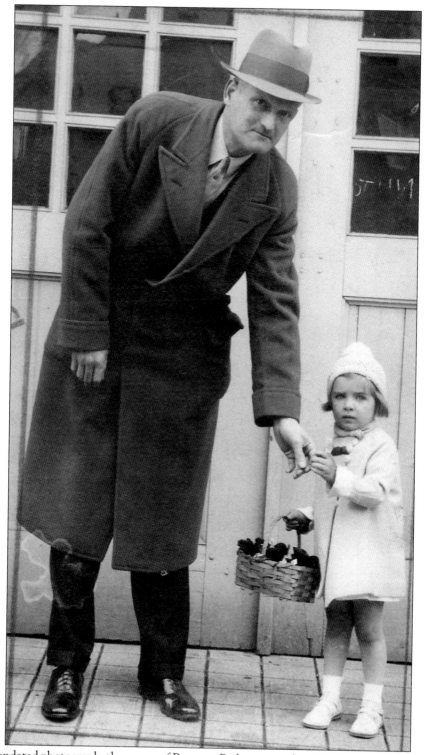

In this undated photograph, the mayor of Prospect Park poses with a young child holding a basket of poppies for a Memorial Day fundraiser. (Courtesy of Joan M. Burrows.)

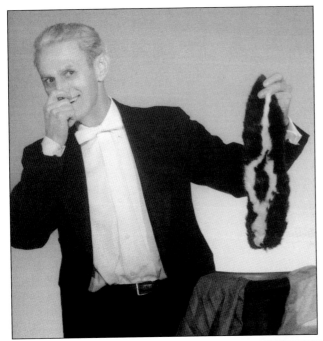

Al "Chick" Harding was the town magician. He loved magic and performed magic tricks as his hobby. He was said to have performed at school functions, church socials and outings, and any place in town that asked for his entertaining. He is shown here dressed in his magician's costume. He has apparently produced a skunk pelt, as he is holding his nose. The nature of this magic trick is open to speculation. (Courtesy of the Harding family.)

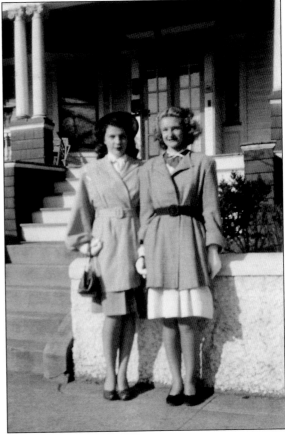

Betty Perler (left) and Mary Goodneighbor are seen here on Easter Sunday in 1947. The young women are dressed in their holiday finery and posing, as was the custom, in front of a Prospect Park home. Goodneighbor later became a celebrity in the world of burlesque. Her stage name was Irma the Body. She grew up in Prospect Park. (Courtesy of Carol Memoli Lamela.)

Louise Clark is seen with her bathing costume in a photograph from a 1965 *Paterson Evening News* article. An avid swimmer, Clark, like many, swam at Lakeside in Haledon. Friends and neighbors from Prospect Park and other towns built a dam at Molly Ann Brook and used the resulting body of water for swimming, an early form of town recreation. At 90, Louise Clark appears to be ready for a swim. (Courtesy of the Passaic County Historical Society, Paterson, New Jersey.)

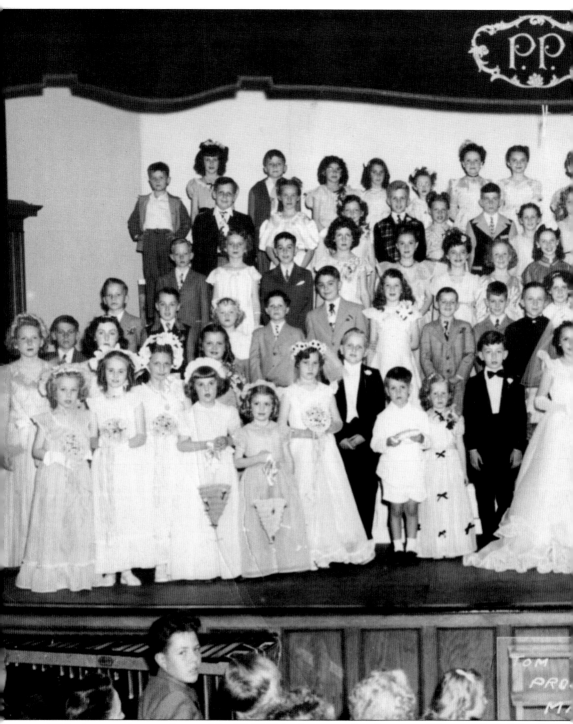

This photograph was taken on May 13, 1949, in the original auditorium of Prospect Park School No. 1. The activity on stage is part of a Tom Thumb wedding. These "weddings" were held in elementary schools across the country as a way to teach children about adult life. Included in the production are the Tom Thumb bride and groom, girls dressed in white gowns, and boys in jackets

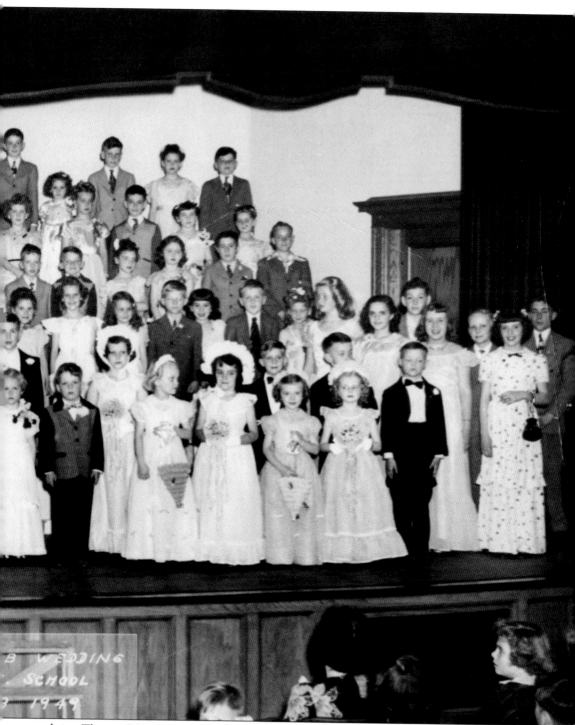

and ties. Thomas F.X. Magura—the boy in the front in shorts, acting as the ring bearer—later became the borough historian of Prospect Park. Scripts could be purchased by the school for the dialogue of this formal event.

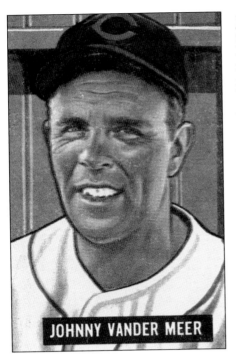

JOHNNY VANDER MEER

Johnny Samuel Vander Meer, the borough's most famous son, was born on November 2, 1914, in Prospect Park. When he was three, his family moved to Midland Park, as did many early Dutch families. Vander Meer graduated from Midland Park School of the Eastern Christian School Association. Vander Meer, "The Dutch Master," was the first and only major-league baseball player to pitch two no-hitters in succession, doing so for the Cincinnati Reds on June 11 and June 15, 1938. He would then go on to play in the 1940 World Series and on several all-star teams. His career lasted 13 years, from 1937 to 1951, with time served in the Navy during World War II. He passed away on October 6, 1997. His stardom is claimed by his birthplace, Prospect Park, as well as where he grew up, Midland Park. It is said that Vander Meer's accomplishment of two consecutive no-hit games will never be duplicated—and to this day, it has not been. The Midland Park Library has an area dedicated to his memory and his career. Shown here are two sides of one of Vander Meer's baseball cards. (Both, courtesy of author.)

Pitcher—Cleveland Indians
Born: Prospect Park, N. J., Nov. 2, 1914
Height: 6 ft. Weight: 190
Bats: Right Throws: Right

Pitch 2 no-hit games in succession in the majors? Why, it can't be done. Or so it would seem. But Johnny has done it. It happened back in 1938 when he was with Cincinnati. On June 11 he hurled a no-hitter against Brooklyn and did the same against Boston on his next mound assignment, June 15. Traded by the Reds to the Cubs for 1950. Released by Cubs, spring of 1951. Signed with Indians.

No. 223 in the 1951 SERIES

BASEBALL

PICTURE CARDS

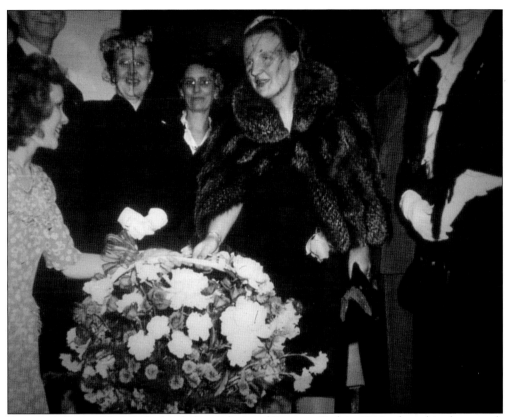

Princess Juliana of the Netherlands (center) visited Prospect Park in 1944, when this photograph was taken. She stayed as a guest at the Hofstra house, which is to this day located in Prospect Park at Haledon Avenue and Ninth Avenue. For decades after, a representative of the royal family visited Prospect Park. A thank-you letter from the queen documents that a fundraiser gala was held at the Hamilton Club in Paterson, New Jersey, to benefit Dutch royalty, for reasons unknown. Juliana later became queen of the Netherlands. (Courtesy of Janet Guariglia and Constance Weber.)

In this undated photograph, Princess Juliana (first row, fourth from right) is being received by women at a reception during her visit to Prospect Park. Note the formality of the occasion and the adornment and variety of ladies' hats. (Courtesy of Janet Guariglia and Constance Weber.)

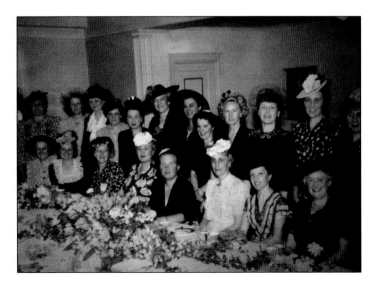

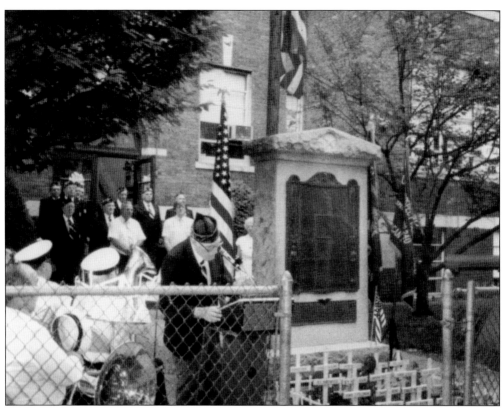

These photographs, taken in the early 1980s, depict a Memorial Day celebration in front of the Prospect Park School. Above, the American Legion commander appears to be making a speech in honor of the men and women from wars past who had served and made the supreme sacrifice. Crosses and a red flower are visible in front of the World Wars I and II Monument. A local band is on the left. Note that the flag is at half-staff.

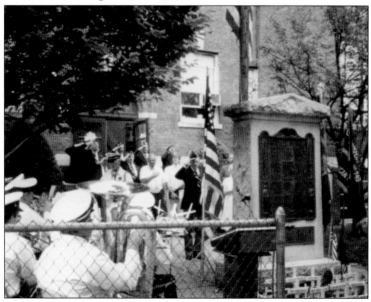

Four

FOUNDATION FOR THE FUTURE
BY KELLY GINART

The heart of community life in Prospect Park lies in education. In the words of a borough resident, "If you want to know what's going on in your community, go to your public school." These words resonate when one examines the history of education in the area. In the early days, children attended a district school located on North Eighth Street near Goffle Road. In time, enrollment increases necessitated the establishment of a separate school district in the Prospect Park area. This led to the selection of a site at North Ninth Street and Brown Avenue as the location of the borough school.

Construction of the frame school began in 1889. During construction, approximately 60 students left the district school on North Eighth Street and continued their studies in a large tent pitched near the construction site, under the direction of David J. Thurston. Inclement weather often disrupted instruction in the makeshift structure. Completion of the school building gave borough residents the opportunity to manage their own educational affairs within the halls of Prospect Park School No. 1, which continues to serve students from prekindergarten through eighth grade.

Public schools in surrounding areas play an equally integral role in the education of Prospect Park's youth, as do private schools. In the early days, the North Fourth Street Christian School, located in Paterson, was an important site for primary instruction. Presently, town residents can elect to send their children to private schools, such as Al-Hikmah Elementary School or Eastern Christian High School, although many of the borough's students attend Manchester Regional High School.

Prospect Park School No. 1 continues to serve students and residents of the borough. It houses the community library, serves as the center for community events, and is the location for the borough's war memorials. Education in Prospect Park creates a foundation for children based on the fundamental values of hard work, service, punctuality, and respect. These values reflect those that the early Dutch families instilled in their children.

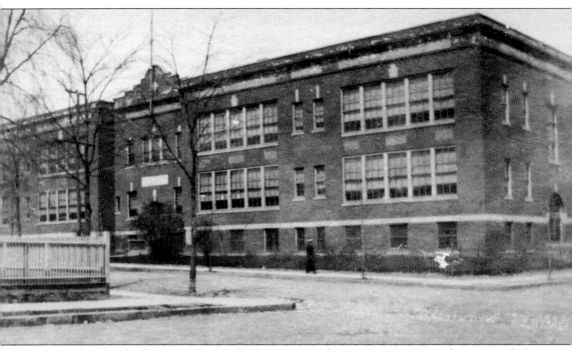

This photograph of Prospect Park School No. 1 was taken in the 1920s from the corner of what are now Brown Avenue and North Ninth Street. Note the absence of mature foliage; the original fencing surrounding the building was later removed. The first school building was a tent. Later, a wooden building was erected, but this was destroyed by fire. Pictured here is the structure that became the permanent school building. Children would listen for the school bell, which was rung every day. They would walk to school in the morning and walk home for lunch, prepared by their mothers. This is one of the earliest existing photographs of the school.

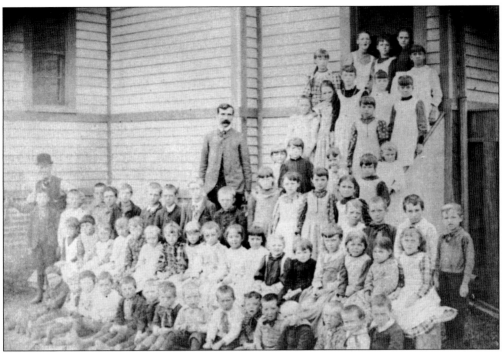

This is one of the first school groups of Prospect Park School. David J. Thurston, the principal, is standing at center. Before construction of the school building (in the background) was completed, Thurston directed the instruction of approximately 69 students in a large tent pitched near the construction site. Inclement weather was a great obstacle for the students and teachers. In fact, strong winds often blew the tent down. Boys and girls would often be seen helping to pitch the tent before lessons could begin.

Shown here is the 1947 seventh-grade class of Prospect Park School No. 1. The photograph was taken in front of the school building. Note that the girls are wearing dresses and many of the boys are wearing shirts and ties. Some are dressed more formally than others. (Courtesy of Joan M. Burrows.)

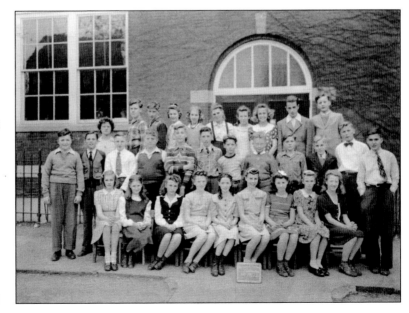

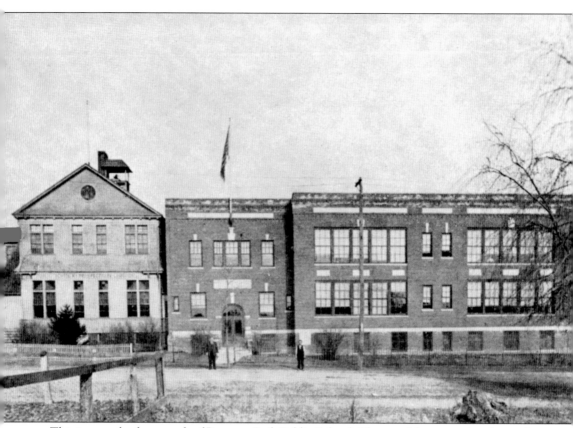

This is an early photograph of Prospect Park Public School. The wood-frame section, located on the far left of the structure, was once known as School No. 6 of Manchester. The building was destroyed by fire in 1911. Note the bell tower at the top of the building. In the early days, it was also used for fire alarms. The bell is still used daily to mark the start of the school day.

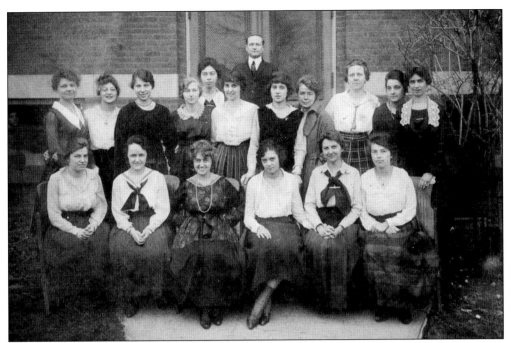

This is believed to be the faculty and the principal teacher, the only male in the photograph, of Prospect Park School No. 1 in the 1920s. In those days, males were the principal teachers, now called the principals, and the classroom teachers were women. They were unmarried and prohibited from being married. Women and teachers were expected to have high moral standards, in concert with the values of the borough. In the 1920s, teaching was one of the few vocations available to women. (Courtesy of Joan M. Burrows.)

This postcard of Prospect Park School reflects changes made to the school after the fire of 1911. Note that the wood-frame structure, once located on the far left of the building, is gone. (Courtesy of Joan M. Burrows.)

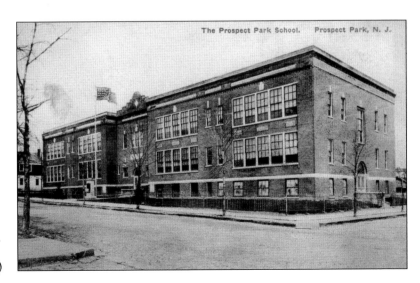

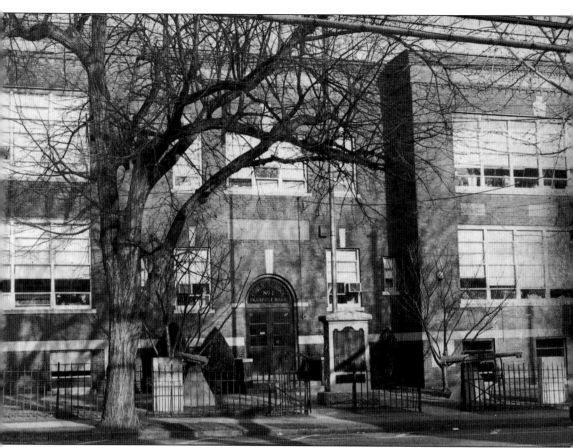

The face of the school building was changed in order to include a tribute to the men and women of Prospect Park who served and died in World Wars I and II. Note the placement of the monument next to the flagpole and the fencing surrounding the monuments, which were relocated from the side of the municipal building. The school name was added to the top of the front door. The school was named Prospect Park School No. 1, even though there is only one public school in the borough. The fencing was later changed, because the pointed tops were considered hazardous.

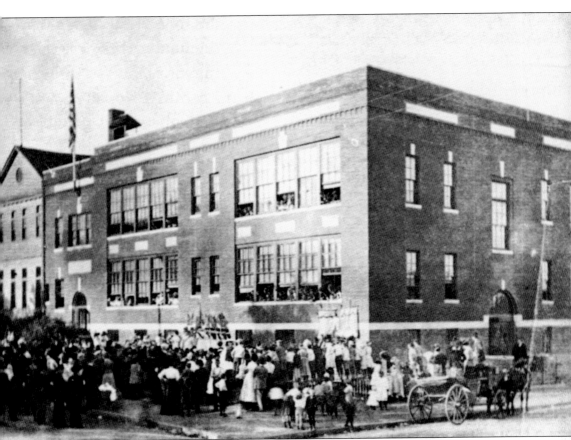

Prospect Park School No. 1 is seen here in the 1920s. Students, faculty, and borough residents are shown looking out school windows and gathering on the front lawn for a flag drill. Such drills were common after World War I, when, after mobilizing hundreds of thousands of men, leaders recognized the lack of citizens' physical fitness. This realization extended to observations of those working in factories and those engaged in manual labor. To address concerns, physical education programs were added to school curricula. Students learned how to march, adding discipline to the newly instituted programs. The Prospect Park School or borough drill team is seen performing on the front lawn of the school in precise formations while holding flags.

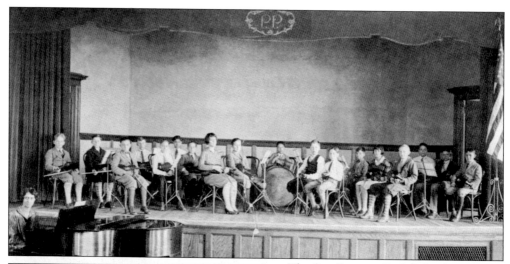

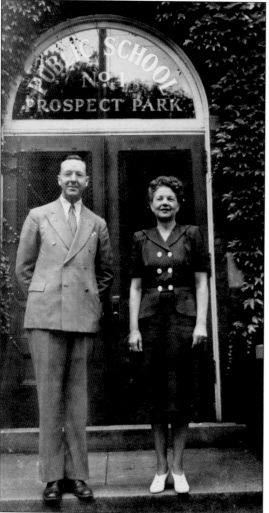

The first Prospect Park School Orchestra is shown in this 1926 photograph, which reflects the variety of extracurricular options available to early students. Note that students are dressed in their Sunday best. The orchestra members are in the auditorium before it was renovated and transformed into a multipurpose gymnasium. The current library, which is opened to borough residents one day during the week, now occupies this location. Borough residents currently utilize the Hawthorne Public Library, but formerly had to go to the Paterson Public Library.

Edmund Viemeister, supervising principal, poses with Amelia Berdan, an eighth-grade teacher. They are pictured in front of the ivy-covered building at an unknown date. In May 1948, the board of education moved to abolish the position of principal, substituting it with a position of teaching principal. The result was an appeal by opponents to the commissioner of education and the New Jersey State Board of Education. The case is a famous one in New Jersey school law. In the end, Viemeister retained his position. (Courtesy of Carol Memoli Lamela.)

The boys of the class of 1947 pose on graduation day (above). Schools typically held formal graduations in this era, since many students did not continue on to high school. Note the ivy walls of the school building and the boys' formal attire. They sport carnations and ribbons over their hearts. The ribbons are blue and white, the colors of the school. The female members of the class of 1947 (right) wear white gowns and corsages of roses. The girls are pictured against the backdrop of the ivy-walled school. In the left background are the cannon, flagpole, and monuments. (Both, courtesy of Carol Memoli Lamela.)

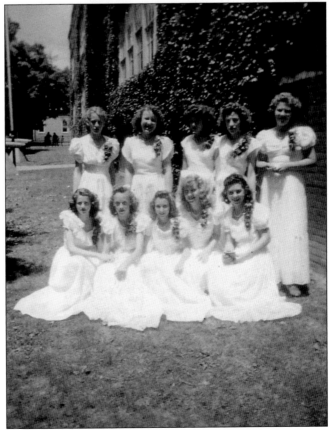

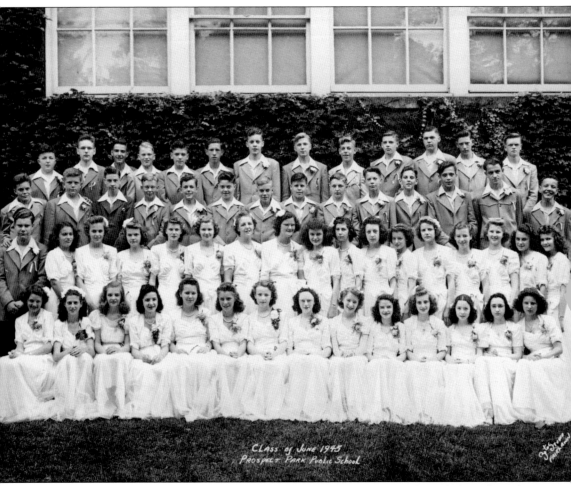

Pictured here is Prospect Park School No. 1's graduating class of 1945. The eighth-grade students are dressed to impress in their formal attire and adorned in the school's colors, blue and white. According to a longtime resident, attending Prospect Park School in the early days meant that boys and girls had to play on separate playgrounds at recess, as was a common trend of the period. Also customary of the period was the fact that the boys' playground would have been larger in size than the one girls were permitted to play on, although both boys and girls shared one set of swings. It is interesting to note that older students served as junior patrols before the borough officially instated crossing guards. In the days of junior patrols, girls were only permitted to patrol close to the school, because it was considered "safer," while boys were permitted to patrol the streets. (Courtesy of Carol Memoli Lamela.)

PUPIL'S REPORT

PROSPECT PARK PUBLIC SCHOOL

BOROUGH OF PROSPECT PARK, N. J.

SCHOOL YEAR............ TERM............

Pictured at right is the cover of a student's report card, titled "Pupil's Report." The grades earned by Joan Popp in her grade 4A class are seen below. Note that letter grades are assigned in all academic subjects, with the exception of history and citizenship (for some reason). Popp had good attendance, being absent six times in the term covered, and she was never tardy to school during this time; she must have heard the school bell ring loudly and clearly each morning. Teacher's comments indicate that "Joan is doing excellent work," is "liked by her classmates," and "is on the Honor Roll," as noted by the four gold stars. Report cards were sent home monthly. (Both, courtesy of Joan M. Burrows.)

Pupil Joan Popp

Grade 4A

	Feb.	Mar.	Apr.	May	June	Av.
½ Days Absent	1	2	1	2	0	6
Times Tardy	0	0	0	0	0	0
Conduct	A	A	A	A	A	A
Reading	A	A	A	A	A	A
Language	A	A	A	A	A	A
Spelling	A	A	A	A	A	A
Writing	A	A	A	A	A	A
Geography	A	A	A	A	A	A
History						
Citizenship						
Science	A	B	A	A	A	A
Health Ed.	A	A	A	A	A	A
Arithmetic	A	A	A	A	A	A
Drawing	A	A	A	A	A	A
Music	A	A	A	A	A	A
Phys. Ed.	A	A	A	A	A	A

MEANING OF MARKS

A—93 to 100—Excellent B—84 to 92—Good
C—75 to 83—Fair D—below 75—Unsatisfactory

Promoted to or retained in Grade 5B.

TEACHER'S COMMENTS AND SUGGESTIONS

Joan is doing excellent work in class and is well liked by her classmates. ★

Joan is on the honor roll. ★

Honor Roll! ★

It has certainly been a pleasure to have had Joan in my class.

Signature of Teacher M. B. Grimes

Prospect Park Public School

Class of 1945

Pictured above is the cover of a Prospect Park Public School diploma. The diploma of Joan Margaret Popp (below) is dated June 21, 1945. Note that the signatures are those of Cora Hofstra, the president of the board of education, and Edmund H. Viemeister, principal. Hofstra was the first female on the school board and one of the first women of the borough to hold public office. Viemeister was employed as supervising principal in 1937, without teaching responsibilities. (Both, courtesy of Joan M. Burrows.)

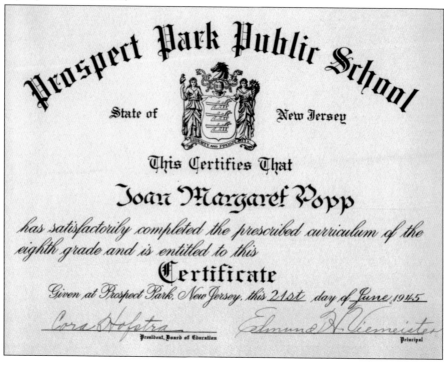

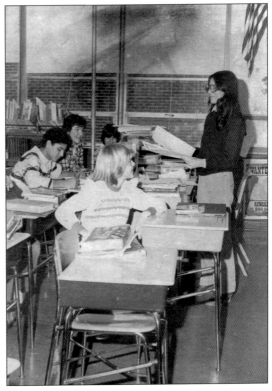

At right, an unidentified teacher conducts class in what seems to be a sixth- or seventh-grade classroom in the 1970s or 1980s. Note here, in contrast to earlier photographs, the less-formal style of the students' dress, and that of the teacher as well. The below photograph, from the late 1970s or the 1980s, shows that classroom instruction also became less formal. These students are diligently working at their desks on what is presumed to be an independent assignment.

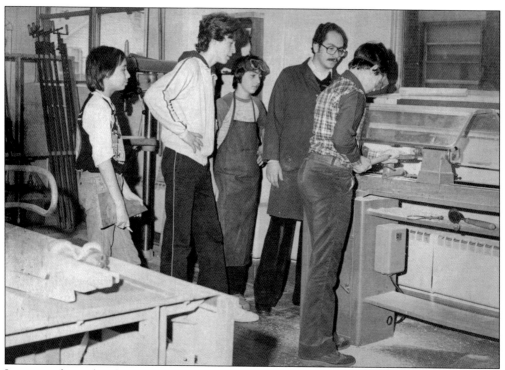

Interestingly, in this shop class from about the same period as the ones depicted on the previous page, four boys observe a demonstration of the use of a wood lathe. Note that the boy working on the lathe has safety glasses, but the other boys around the machinery do not, in contrast to safety measures in present-day shop classes. Since the population of Prospect Park included many craftsmen, the manual arts had a significant place in the school curriculum, though participation by girls came later.

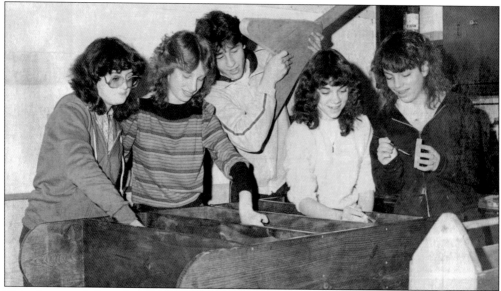

This photograph from the mid-1970s depicts the result of a law requiring schools to have gender-mixed classes in all subject areas. In this shop class, four girls and a boy work on a project.

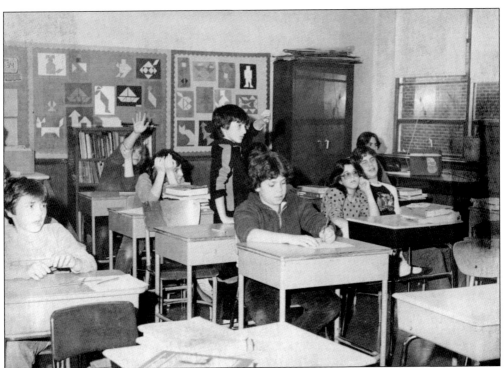

Eighth-grade teacher Florence Cimins is shown at right. The hallmark of many of the teachers at Prospect Park School No. 1 was their teaching style, which affirmed orderly classrooms, punctuality, and achievement. Note the blackboard and the line of white along the chalk trough, which may be chalk dust. Clearly, the teacher was the center of classroom instruction. Pictured above are an unidentified classroom and students from around the same time period. They seem to be actively engaged in instruction.

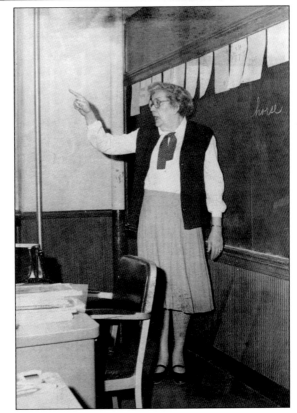

Pictured here are three smiling students. The student in the center may be coming to or from shop class.

92

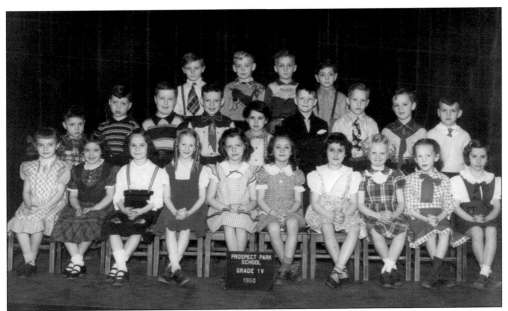

This first-grade class photograph from Prospect Park School was taken in 1945. At far right in the second row is a young Thomas F.X. Magura, who would later be honored as borough historian.

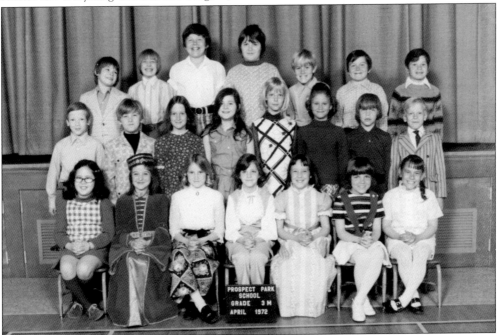

Class pictures are a tradition in American schools, and Prospect Park was no exception. Here, the children of a third-grade class pose in 1972. Note that there remained an air of formality of dress, with one boy wearing a tie and others wearing sports coats. The colors of the clothes, which cannot be seen, reflect the fashions of the time. The girls are wearing dresses, with the exception of the student in the first row, who wears some type of pants suit, which was in the early stages of being permitted as school wear. One girl wears the native dress from her country of origin (not specified).

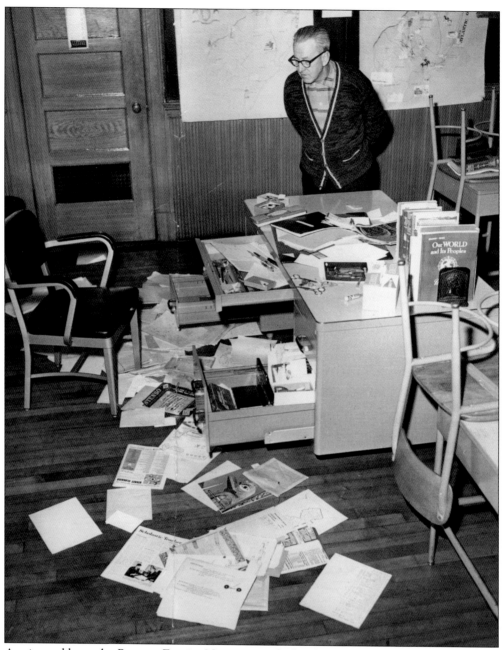

As pictured here, the *Paterson Evening News* reported a break-in and apparent vandalism of the school. The reported act took place in March 1964 and appears to have caused some minimal damage to this classroom. The man observing the damage is unidentified. (Courtesy of the Passaic County Historical Society, Paterson, New Jersey.)

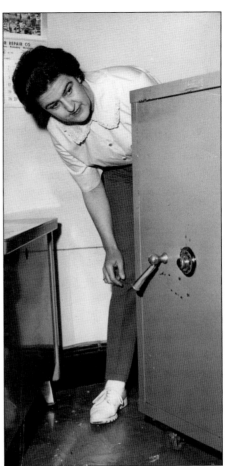

In the mid-1960s, it was reported that there was a robbery in Prospect Park School No. 1. To many longtime residents, it remains a mystery. While it was reported in the newspaper, there seems to be little knowledge of the circumstances behind the alleged robbery. To the right, an unidentified person examines the safe in question, which is believed to have been located in the school's office. It appears from the below photograph that some minor damage was done to the window on one of the doors to the school. The person pointing to the damage is unidentified. (Both, courtesy of the Passaic County Historical Society, Paterson, New Jersey.)

This is a classroom in the late 1970s. Note the teacher-centered classroom, which was the norm in schools during the period, and the dress of the teacher, who appears to be wearing pants of some type. She is writing on the blackboard, and to her right are roll-down maps—the visual aids of the time.

Gene Pollis was a physical education teacher. The gym and the auditorium were used as multipurpose facilities. Children had gym time each week.

Pictured here is one of the school secretaries diligently at work. Note that the technology had been modernized, as the unidentified secretary is using what appears to be an electronic typewriter. Prior to that time, most typewriters were of the manual variety.

Thomas Vannatta was a teacher, coach, principal, supervising principal, and, later, superintendent from 1965 to 2002, when he retired. Vannatta was a highly regarded professional who devoted his entire career to the children and families of Prospect Park. One of his many accomplishments was securing a bonding authorization from the borough of Prospect Park to commence a building renovation and addition project. In an interview with Vannatta, he and his wife, Clair, expressed their affection and fondness for their years of service in the borough school.

Dr. James Barriale followed Thomas Vannatta as superintendent of the Prospect Park School District. Dr. Barriale came to Prospect Park from Manchester Regional High School. He served in his capacity as superintendent for a short time, unfortunately passing away early in his tenure. A memorial quilt hangs in the library of the school in his memory.

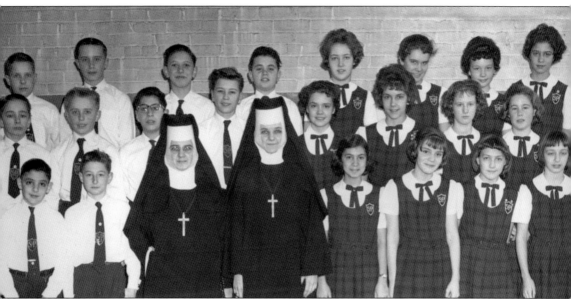

This is a class picture from St. Paul's Roman Catholic School, which was located in the northwest corner of Prospect Park, on Haledon Avenue. In the 1960s, St. Paul's school enjoyed a strong enrollment of children from Catholic families. Shown here are two of the parish nuns and the children in their school uniforms. (Courtesy of the Passaic County Historical Society, Paterson, New Jersey.)

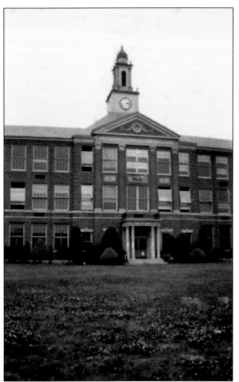

Since Prospect Park School No. 1 served kindergarten through eighth grade, the children who went to public schools went to high schools in other towns. In the very early years, some of the children went to Paterson Central High School, which is no longer in existence. Later, many went to Hawthorne High School (pictured), which was in the neighboring borough and a short distance from the center of Prospect Park. (Courtesy of Carol Memoli Lamela.)

In the late 1950s, Prospect Park, Haledon, and North Haledon came together to form a regional high school, Manchester Regional High School. Many of the children from the borough continue to attend Manchester, although many choose other public and private schools outside the borough. (Courtesy of Justin D. Eldridge.)

Five

IN THE FACE OF CHANGE
BY BRIA BARNES AND AMANI KATTAYA

The ticking clock begins with the sun,
unveiling the day and tasks to be done.
A borough arises to seize the day,
as neighbors greet with kind words to say.
With work and play just up the block,
one might believe that time had stopped.
Nestled deep within the borough's kin,
is where this fruitful story begins.

Prospect Park, a community rooted in rich Dutch history, has blossomed through several seasons of change into a far different borough, taking on a new face of change in its 115-year history. As decades passed, the community expanded its cultural palette, from mostly Northern European to an international "fruit bowl," as it was affectionately titled by local residents. The borough, once mostly of Dutch ancestry, is presently a mix of Hispanic, African American, Middle East–Arab, and vestiges of the Northern European population of the past. Prospect Park, racially and ethnically diverse, maintains the core values of religion and respect. The presence of safe, clean, and quiet streets and the absence of bars and liquor stores are a testament to the borough's dedication to its values. Once adhering to strict blue laws, the borough remains a dry town, and businesses are still closed on Sundays. Although the cultural context has changed, it is evident throughout the borough that many of the founding core values remain.

Some community staples, events, and routines have been maintained; many have faded with time; and new ones have emerged. The antique bell inside Prospect Park School No. 1 is still rung daily. Strict blue laws are no longer enforced on Sundays. The newly started Prospect Park Day has become a joyous community event.

The borough's transformation mirrors many communities in North Jersey and across America that have undergone profound cultural and demographic changes. This book concludes with a photographic essay of Prospect Park today, albeit an incomplete one. Here, the reader can reflect on the dramatic changes that have taken place in the community's 115 years.

The ticking clock keeps track of time,
as children grow and newcomers find.
Find their way to Prospect Park,
for brighter days and brand new starts.

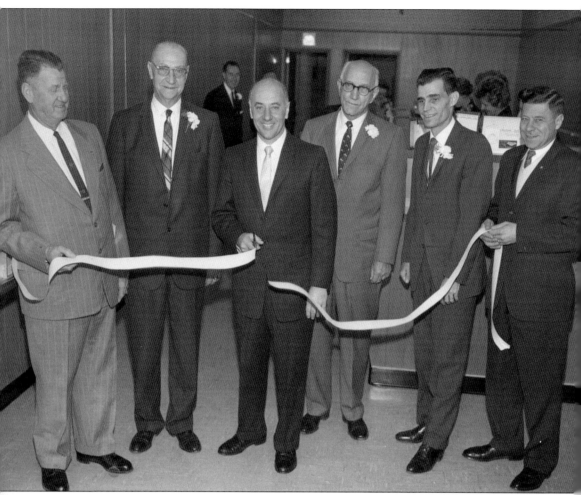

Shown here is the 1961 grand opening of the Prospect Park Savings and Loan Association's new offices. The savings and loan association was one of two financial institutions in the borough, the other being Prospect Park National Bank. The savings and loan association was established to assist residents in the borough and the surrounding area to manage, handle, and keep track of their funds. The Prospect Park Savings and Loan Association, originally named Prospect Park Building and Loan Association, has since moved from the borough, but the original building still stands. (Courtesy of the Passaic County Historical Society, Paterson, New Jersey.)

Pictured here is the Prospect Park National Bank at its Haledon Avenue location. Initially, the bank was formed in 1925, but did not officially open its doors until December 31 of that year, on the corner of North Sixth Street and Alvin Avenue. The bank had a capital of $50,000, in surplus of $25,000 deposits—exceeding the $100,000 mark on the opening day of the new institution. Amazingly enough, the unwavering confidence that residents of Prospect Park had in this bank proved to be well warranted as the Depression had little effect on the bank's ability to meet its obligations. Prospect Park Bank was the financial foundation of the community that was able to withstand President Roosevelt's decision to close banks that were not financially solvent during the 1930s. This story has resonated as the testament to the responsible management of funds by the owners of a borough staple. (Courtesy of Janet Guariglia and Constance Weber.)

Raymond Wilkins was known around town as the man who captured life's finest moments on film. He was the school photographer who took snapshots of generation after generation of Prospect Park children as they smiled for their class pictures. He also photographed weddings, retirement parties, and other memorable occasions for residents of the borough. In addition to being a school photographer, Wilkins owned and operated a tuxedo shop on Haledon Avenue that supplied fine threads to many of Prospect Park's gentlemen, both young and old. This tuxedo shop remains in business today; under new management, it has been renamed Malzone Tuxedos.

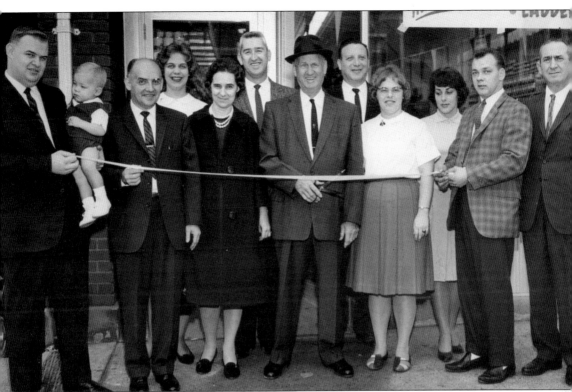

Shown here is the grand opening of Verblaauw's hardware store. Opened in November 1963, the hardware store was the place to purchase home-improvement goods, such as hammers, nails, and paint. Every necessity for any project in and around the home, for building or just plain maintenance, could be found stocked neatly on the shelves. Like many local businesses, Verblaauw's was a family-owned establishment, where brothers, sisters, aunts, uncles, and cousins were known to work. Many customers had store accounts, based on their good names. This is another testament to how the value of integrity resonated in the borough—from its early history, down through the decades, to today. People would walk into Verblaauw's and say, "Charge it to my account," and walk out with arms full of tools or projects to complete. (Courtesy of the Passaic County Historical Society, Paterson, New Jersey.)

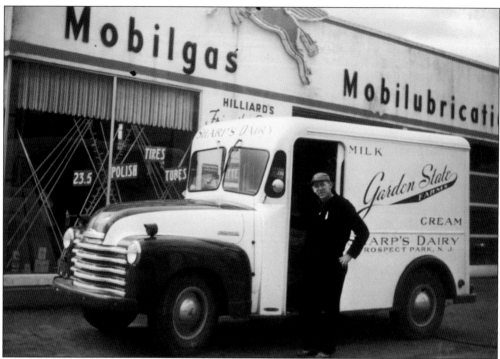

As in most small towns in America, sunrise brought daily milk delivery to Prospect Park. The below photograph, apparently from the 1950s, is a reminder of the simple things that made Prospect Park a truly close community. Residents left their milk boxes out for replenishment by the local milkman. In this photograph, Bill Sharp, the local milkman for decades, with his familiar and smiling face, is cheerfully delivering milk to houses in the borough. Pictured above is the Sharp's Milk truck, also adorned with the Garden State insignia, which made its way through the borough each morning supplying this breakfast essential. Longtime residents report that when the Garden State milk store opened on North Eighth Street, the proprietors wanted to stay open on Sunday. However, with just the mention of a boycott on the horizon, the owners were reportedly encouraged to remain closed that day of the week. (Both, courtesy of Kathy Sharp Anema.)

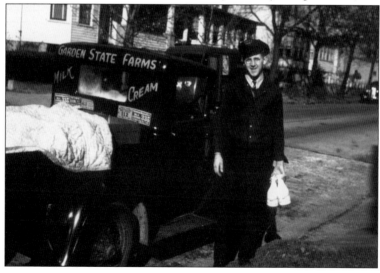

Pictured here is the Haband Company, a clothing firm whose headquarters were in the borough. The company's advertisements for the men and women's clothing it assembled were featured in the back of Sunday magazines and papers. As the owner once said, "[We] are just a mom-and-pop store." Haband employed men and women who lived within walking distance of the factory, as well as high school and college students in the summer and, in some cases, after school. The Haband Company eventually moved from Prospect Park to another location. This photograph shows its borough location, with the company's necktie logo. (Courtesy of Janet Guariglia and Constance Weber.)

Shown here is the once booming factory located in Prospect Park that was home to several small textile shops. Many of these shops were convenient to local residents, particularly women, some of whom are shown here. Because of the close-knit feel that inevitably defined this one-square-mile borough, these women were able to enjoy lunch with their families in the comfort of their own homes. This was just one way that Prospect Park upheld and maintained its values and, more important, the sanctity of the family. The borough's size allowed for a simple, leisurely walk up the street to the door of a friend's home, the school one's children attended, or, in the case of these women, the place of employment.

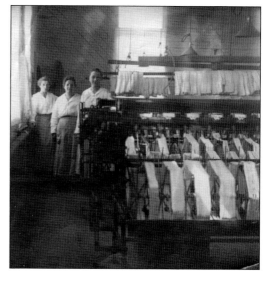

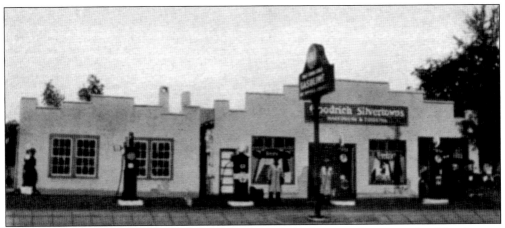

The businesses of Prospect Park had many faces throughout the years. One example of the changes that took place is the Borough Garage, which was once the place to obtain gasoline, tires, and storage batteries. The Borough Garage was located on North Eleventh Street. Like many local service stations today, the Borough Garage changed its use, from a service station for cars to a more modern facility. (Courtesy of Eastern Christian School Association.)

In this case, the garage became a Haband retail store. Haband, while primarily a mail-order business, had several retail outlets, including what was once the Borough Garage.

The Carousel Luncheonette was a favorite of a generation of Prospect Park young people, who went there to meet friends, play pinball, and enjoy a soda and a quick bite to eat. On the *Facebook* page "If you grew up in Prospect Park," many people write about their affection for the luncheonette and for the people who owned and operated it. In this 1990s photograph, the window indicates that, in addition to being a luncheonette, the Carousel sold lottery tickets and cigarettes.

Pictured here is the Tucanes Restaurant, which called itself "The Family Place." The Tucanes Restaurant, which replaced the Carousel Luncheonette, is still located on the corner of Brown Avenue and North Eighth Street. Tucanes serves breakfast, lunch, and dinner, and it prides itself on serving authentic Costa Rican cuisine. The Carousel and Tucanes demonstrate the change taking place with respect to commercial establishments. (Courtesy of Justin D. Eldridge.)

This is Carmen's unisex hair-styling salon. A slogan on the awning indicates that Carmen's is a family salon, and the front window includes information in both English and Spanish. The introduction of languages other than English shows how the population of Prospect Park is becoming diverse. Today, Carmen's is the GQ Salon.

Aiello's Fruit and Vegetable Market opened on North Eighth Street in the 1930s. The proprietor was Antonio Aiello. Later, the market moved to its present location on Haledon Avenue. Aiello's, which continues to be owned and operated by the Aiello family, recently celebrated its 75th anniversary at the Haledon Avenue location. A visitor to Aiello's will find a family member ready to cheerfully serve him or her and to also give a quick history of Aiello's in Prospect Park. (Courtesy of Justin D. Eldridge.)

Pictured at right is the windmill crest made by Passaic County Technical High School students that proudly hangs in the borough hall chamber. Shown below is an enormous Dutch traditional shoe—the wooden clog. The shoe, which was used as a prop and possibly part of a parade float, is adorned with the American Legion logo and the local post's number, 240. American Legion Memorial Post 240 is proudly known as the "Wooden Shoe Post." The Dutch clog is seen as a defining emblem of the Prospect Park community because of its ties to the borough's founders.

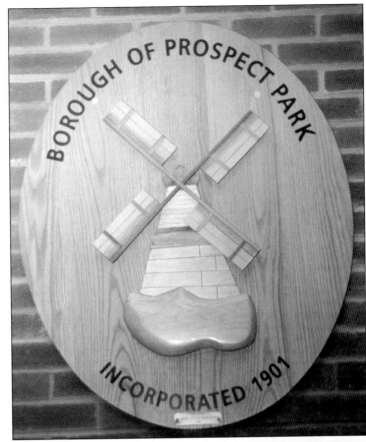

In Prospect Park, there are two major political organizations that allow residents to exercise their rights and speak their minds: the Democratic Club (above) and the Republican Association of Prospect Park (below). Politics has always been a major part of the American experience, especially in small towns. Prospect Park, like most other communities in America, has political organizations that meet regularly and involve members of the community from all backgrounds, ethnicities, and nationalities. These photographs were taken in the 1990s. The men and women in both clubs maintain the tradition of civic engagement in the borough, regardless of their political and philosophical leanings.

The photographs on this page show members of the borough's staff in the late 1990s. Pictured above are women who served the borough at this time. Many of the women who held municipal jobs lived locally and worked part time. Pictured below is the Borough of Prospect Park Board of Adjustment. The board plays a key role in land usage throughout the neighborhood. Since the borough is small in area, about one-half square mile, the board of adjustment looks after changes that property owners want to make on their dwellings and makes rulings with respect to the current master plan zoning. Despite its small size, however, the borough is densely populated and has a mix of residential, commercial, and industrial structures. Judith Critchley (first row, second from left) served as borough clerk, payroll clerk, board of adjustment clerk, planning board clerk, and court administrator. Critchley is revered for her many years of service to the borough. The other individuals in the photograph are unidentified.

Shown here is the Borough of Prospect Park Board of Health. Serving on this board is a prestigious appointment, since, traditionally, the board of health has looked after the well-being of residents, young and old.

As the Police Athletic League, the Boys Club, and other civic organizations disbanded, the Borough of Prospect Park assumed the role of maintaining activities for residents of all ages. The board of recreation and the administration organize baseball teams and other activities that take place in the school and in Hofstra Park during the summer.

Pictured above is the Prospect Park Board of Education, which has played a prominent role in the governance of the school district throughout the borough's history. The group is composed of nine members. Also of importance, the Parent Teacher Association helps organize field trips, book fairs, pizza parties, and holiday gatherings. It hosts fundraisers, one of which is the traditional holiday party in December. The PTA, shown below, addresses issues that are important not only to teachers, but also to public school superintendents and students. This organization allows parents to be more involved and to build closer relationships between the home and the school.

The Prospect Park School District Board of Education office is located in the former American Legion Hall on North Eighth Street. Prospect Park is a one-school borough. Pictured at left is the cornerstone of the Prospect Park School. Laid in 1907, this is the original cornerstone from the board of education building. Of the 10 names on the cornerstone, the one that stands out is Adrian Struyk, who was the first mayor of Prospect Park and who was said to have loaned the borough money to start the local government. His name and those of other pioneers are stamped on the cornerstone as a testimony to their service. (Both, courtesy of Justin D. Eldridge.)

This undated photograph shows the maintenance and custodial staff of Prospect Park School No. 1. The maintenance staff plays an essential role in the school, supporting the education system through the provision of a clean and tidy learning environment. A visitor to Prospect Park School today would find that the wooden floors on the first level are buffed to a standard of cleanliness that would have made the early residents and maintenance workers proud. Keeping with Dutch roots and traditional values, the Prospect Park School has always been, and continues to be, a very well-maintained pillar of the community. Some might say the school is spotless.

Seen here are the school crossing guards. Since most children walk or are walked to school by parents or older siblings, the safety of the children is essential. A longtime resident spoke fondly of the student safety patrol, which came before the adult crossing guards. It was an honor to be dressed in the junior patrol uniform and to help children on their way to school. It is not clear when the police department assumed responsibility for the safety of students, by the use of adult crossing guards. However, the safety of the borough's students has always been a priority.

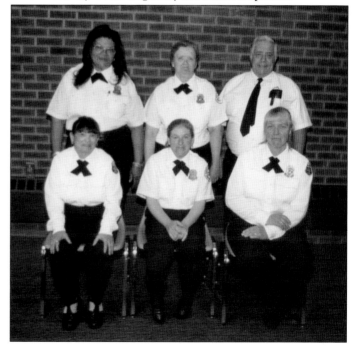

Prospect Park School No. 1 is located at 94 Brown Avenue. The school district enrolls 895 students from preschool to grade eight. Its population mirrors the demographic trend of many urban communities in New Jersey, with representation of various ethnic, religious, and racial backgrounds. The role of the school has changed through the years from a kindergarten–8 to a prekindergarten–8 facility. The building was renovated and expanded to accommodate the changing educational needs of the children. Where there once was a large playground for the students, part of a new addition now stands. (Both, courtesy of Justin D. Eldridge.)

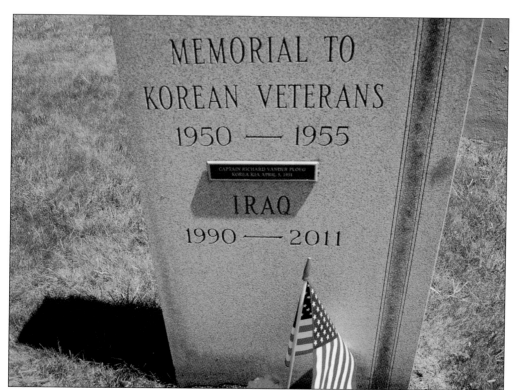

MEMORIAL TO
KOREAN VETERANS
1950 —— 1955

CAPTAIN RICHARD VANDER PLOEG
KOREA KIA APRIL 8, 1951

IRAQ
1990 —— 2011

These photographs feature monuments located in front of Prospect Park School No. 1. These newly erected monuments honor men and women of the US Armed Forces who have served in the Korean and Vietnam Wars, as well as the wars in Iraq and Afghanistan. The veterans and those who have paid the supreme sacrifice are honored and respected for their service to their country. (Both, courtesy of Justin D. Eldridge.)

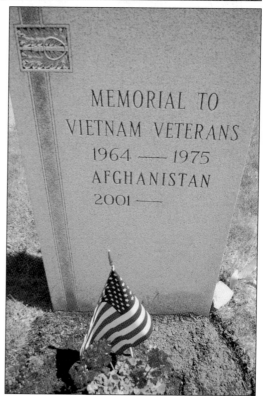

MEMORIAL TO
VIETNAM VETERANS
1964 —— 1975
AFGHANISTAN
2001 ——

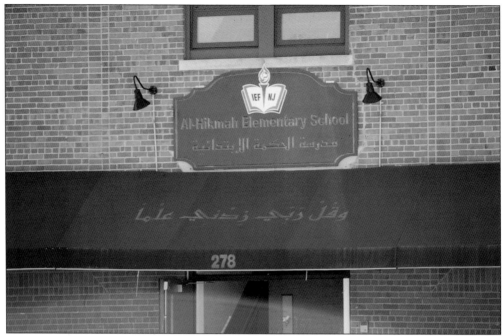

Pictured on this page is the Al-Hikmah School, the Islamic school in the borough. Originally, the school building was home to Eastern Academy, but it now houses a place of learning of a faith that has found its way into the Prospect Park community. Al-Hikmah currently educates children from prekindergarten through sixth grade. Its enrollment is approximately 282 students, with 21 teachers. This school is accredited and/or affiliated with the Islamic School League of America. Most students who attend Al-Hikmah continue on to Al-Ghazaly Islamic School for seventh to twelfth grades. (Both, courtesy of Justin D. Eldridge.)

These are the covers of the 75th- and 100th-year anniversary books created to commemorate the history of Prospect Park. On the covers, evidence of the borough's Dutch roots can be seen in the depictions of blond-haired children picking flowers by a windmill. Not only is the windmill the seal of the borough, it is also placed throughout the community, in the borough hall, and decorating residential homes. Another prevalent symbol of the borough's roots shown on the covers is the Dutch clogs, which are a nod to the past.

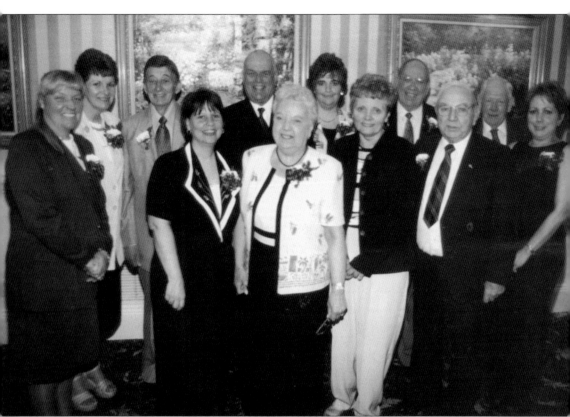

In 2001, a group of longtime citizens of the Borough of Prospect Park came together to tell the story and to commemorate its 100-year history. With the help of local businesses and dedicated citizens, the group produced a souvenir journal dedicated to the residents of Prospect Park. The journal recorded the history of the community. As stated in the foreword, "the pictures and remarks tell a story of dedicated people who have built and made Prospect Park a wonderful town to live in." The foreword goes on to say that "the Borough founders were predominately of Dutch descent, but all that has changed. Now people of many origins contribute to Prospect Park's greatness."

Shown here is the boulder-type monument of Hofstra Park, dedicated to the people of Prospect Park and the Hofstra family. The family donated the land for the establishment of a park, which was later named after them. Hofstra Park today is an extensive park system that includes walking trails, tennis and basketball courts, a baseball field, and a water park. A picnic shelter is located in the park. Just as earlier generations of Prospect Park children and families picnicked and played in the Hayfields, Hofstra Park provides for the same recreational use for the borough's residents today. (Courtesy of Justin D. Eldridge.)

Prospect Park Day is a new tradition, held at Hofstra Park each fall. On a clear day, a person can stand on the edge of Hofstra Park and get a view of the New York City skyline, though one would have to be careful not to disturb the deer that roam the woods.

The Hofstra house holds historic meaning for the Borough of Prospect Park. The house is seen here in a contemporary photograph. Princess Juliana of the Netherlands stayed in this home in the 1940s. The house remains, for the most part, as it was in the past. The exterior has not undergone many changes. There are few historic dwellings in the region that can make claim to housing royalty, let alone a princess who later became a queen. It is a house and a story that is embedded in Prospect Park's history. (Courtesy of Justin D. Eldridge.)

Just as this publication began with a scenic overlook of the city of Paterson from the late 1800s, the photograph on this page was taken from a similar vantage point—the corner of Haledon Avenue and North Eighth Street—with a view looking south toward Paterson. The landscape has undergone a dramatic change in the course of the last 115 years, as businesses line the paved street of Haledon Avenue where open spaces once dominated. In the distance, rather than open fields, is the former "Silk City" of Paterson. (Courtesy of Justin D. Eldridge.)

The authors are faculty and students of William Paterson University of New Jersey. They are, from left to right, Amani Kattaya (class of 2015), sociology and early childhood education (P–3 with TSD); Megan Perry (class of 2014), summa cum laude, psychology; Eman Al-Jayeh (class of 2015), honors student, communication disorders and anthropology (minor); Bria Barnes (class of 2015), honors student, English and elementary education (K–6, 5–8); Kelly Ginart (class of 2016), honors student, English, anthropology, and elementary education (K–6, 5–8 with TSD); and Paige Rainville (class of 2015), honors student, Spanish and early childhood education (P–3, K–6).

Ronald P. Verdicchio, EdD, is an associate professor at William Paterson University in Wayne, New Jersey, where he specializes in anthropology and education and communities and schools. His doctorate is from Teachers College, Columbia University and he is a proud alumnus of William Paterson University of New Jersey (Paterson State College).

DISCOVER THOUSANDS OF LOCAL HISTORY BOOKS FEATURING MILLIONS OF VINTAGE IMAGES

Arcadia Publishing, the leading local history publisher in the United States, is committed to making history accessible and meaningful through publishing books that celebrate and preserve the heritage of America's people and places.

Find more books like this at
www.arcadiapublishing.com

Search for your hometown history, your old stomping grounds, and even your favorite sports team.

Consistent with our mission to preserve history on a local level, this book was printed in South Carolina on American-made paper and manufactured entirely in the United States. Products carrying the accredited Forest Stewardship Council (FSC) label are printed on 100 percent FSC-certified paper.

MADE IN THE